CHANGING
SCHOOLS
THROUGH
THE ARTS

CHANGING
SCHOOLS
THROUGH
THE ARTS
The Power of an Idea

Jane Remer

Foreword by John I. Goodlad

Sponsored by:

The Exxon Education Foundation

The JDR 3rd Fund

With Administrative Support From:

The New York Foundation for the Arts

McGraw-Hill Book Company
New York St. Louis San Francisco
London Paris Tokyo Toronto

1 2 3 4 5 6 7 8 9 0 DODO 8 9 8 7 6 5 4 3 2 1

Thomas H. Quinn and Michael Hennelly were the editors of this book. Eileen Claveloux deBur was the designer, and Thomas G. Kowalczyk supervised the production. It was set in Souvenir Light by IceType.

Printed and bound by R. R. Donnelley and Sons, Inc.

Library of Congress Cataloging in Publication Data
Remer, Jane.
 Changing schools through the arts.

 Bibliography: p.
 Includes index.
 1. Arts—Study and teaching—United States. I. Title.
NX304.R45 700'.7'073 81-8328
ISBN 0-07-051847-5 AACR2

For Duds, David, Abby, and Harry

CONTENTS

Foreword by John I. Goodlad *xi*

Acknowledgments *xv*

Chapter 1
 INTRODUCTION 1
 The Promise of a Powerful Idea: All the Arts for all God's
 Children
 The Purpose of this Book
 On the Bias: A Bit of Personal History
 Belling the Cat: What is AGE?

Chapter 2
 NEW YORK CITY: BIRTHPLACE OF THE CONCEPT
 OF SCHOOL DEVELOPMENT THROUGH THE
 ARTS 9
 Balancing the Equation: Edythe Gaines and the Learning
 Cooperative
 Solving the Problem of "Bigness:" Networking and
 Collaboration
 Design for Change: The Arts in General Education (AGE)
 Manifesto
 "All the Arts for All the Children," A Joint Venture
 between the New York City Public Schools and the JDR
 3rd Fund
 The Goal, the Five Main Characteristics, the Change
 Theory and the Process for Achieving it Through AGE
 Planning the Program: The Dry Martini Formula
 Main Features of the School Identification Process
 Original Categories of Schools in the AGE Network
 Criteria for Participation in AGE
 Outcomes of the Citywide School Identification Process
 Biting the Bullet: A Bloodless "Revolution" with the Arts as
 the Instruments of Change

Chapter 3
 GUIDELINES FOR AGE PROGRAMS: THE
 LEAGUE'S PROCESS MODEL 29
 Considerations for School Systems Interested in AGE
 Programs

The Concept and the Process
Under Certain Conditions
Getting Started
Building the Program at the Grass Roots Level: School
 Development Through the Arts
Mid-Course Corrections
Extending the Concept, Enlarging the Network—or Both

Chapter 4
SCHOOL DEVELOPMENT THROUGH THE ARTS 43
The Concept of School Development
The Characteristics of School Development: The Process,
 the People, the Conditions
"Why the Arts, Not Artichokes?": A Rationale for the Arts
 in Education
The Characteristics of School Development Through the
 Arts
Some Outcomes to Anticipate
School Development Through the Arts and the Broader
 Aims of Education
"This is Not a Santa Claus Project, But . . .": AGE and
 What's In It For You

Chapter 5
*A DAY IN THE LIFE OF AN AGE DEMONSTRATION
SCHOOL: P. S. 152 BROOKLYN* 61
At Least Two Gingko Trees and a Kiosk Grow in Brooklyn
Profile of the School
When is a Day a Typical Day?
The Visit Schedule
School Climate and Environment
Evidence of AGE in the Teaching and Learning Process
The Principal as Leader: "We are such stuff as dreams are
 made on"
The Problems
The Impossible Dream?

Chapter 6
*THE LEAGUE OF CITIES FOR THE ARTS IN
EDUCATION: SIX VARIATIONS ON A THEME* 79
How Members Were Identified: One by One
The Fund's Criteria for a Partnership: Ten Characteristics

of School Systems That Have Developed Effective AGE
Programs
The Unusual Nature of the Partnerships
The Need and Opportunity for a National Network:
Formation of the League
The League's Mission Statement and Declaration of Intent
League Activities: Business Meetings, Site Visits, and the
Giraffe
AGE Proves to Be Adaptable: Thumbnail Sketches of
League Programs

Chapter 7
NETWORKING AND COLLABORATION 95
"I Don't Mind Being Lonely If You Are Lonely, Too": The
Goodlad Factor
A Definition of Networking: Beyond the Rolodex
How Networking Can Build, Maintain and Expand AGE
Programs: Two Examples from the League
"The Perils of Pauline" and "The Pedagogical Party
Line:" New York City Revisited
A Study in Contrasts: The Seattle Story
The Benefits of Networking According to AGE
Practitioners
A Few Last Words on the Subject

Chapter 8
PIECES OF THE PUZZLE 109
A Lick and a Promise
Classroom Teachers: The Heart of the Matter
Arts Specialists: Quality Control
Artists: The Question from Kathryn Bloom
Arts Resource Teams: Flying Squads for Consulting and
Technical Assistance
Parents and Community Volunteers: An Invaluable
Resource
Consultants and Authorities in the Field: The Answer
Depends on the Question
Colleges and Universities: Slow But Sure
Professional Associations and Teacher Unions: Untapped
Resources
School Boards: Financial and Political Advocates
Advisory Committees: Marshalling the Community

Private Foundations and Corporations: Seed Money
 Sources
State Education Departments: Natural Mechanisms for
 Expansion
Arts and Humanities Agencies and Endowments
The U.S. Department of Education and the Education
 Program of the John F. Kennedy Center for the
 Performing Arts

Chapter 9
SUPPORT SYSTEMS: WHAT WE HAVE AND WHAT
 WE NEED 125
 Leadership Training
 Staff and Curriculum Development
 Research and Evaluation
 Documentation and Dissemination
 Financing

Chapter 10
TALLYING UP AND LAYING THE GAUNTLET
 DOWN 135
 In Retrospect
 The Significance of the League
 Current Status: Six Cities in Search of A Hub
 A Call for Action: A National Task Force on the Arts in
 General Education

Appendix A:
CRITERIA 145
 "Community Arts programs and Educational
 Effectiveness in the Schools"
 The Role of the Artist in School Development Programs
 Joint Planning: Some Questions to Raise
 Profile of a One-Week Artists Residency in an AGE School

Appendix B:
LEAGUE OF CITIES ADDRESSES 151

A Selected Bibliography 153

Index 159

FOREWORD

This book is about the arts in schools and how to establish a firm place for them there. Throughout its pages, Jane Remer presents a convincing case for the role of the visual arts, music, dance, drama, architecture, and aesthetics in educating boys and girls. Her argument ranges over the value of the arts for their own sake to their usefulness in enhancing other fields and in kindling the interest in learning of students not otherwise identifying with the expectations of schools. She is convincing.

But Jane Remer also is "streetwise." She has been in and around schools for years as educator, mother of two, foundation executive, and consultant. She knows that ideas, however good, do not get into schools by immaculate conception. A long and sometimes painful process is involved. The curriculum always is full; instructional time is finite. For centuries, mathematics and language arts (reading, spelling, writing, etc.) have dominated elementary school programs, today averaging well over fifty percent of the instructional week—and up to seventy percent in some schools. Everything else usually is regarded as secondary. Rhetoric alone, however convincing, will not bring the arts into schools. Strategies are required.

In addition, then, to addressing the role of the arts in schools, this book presents strategies for getting them there. These strategies combine a considerable amount of extant knowledge about processes of change with less well-established insight into the particular potential of the arts for facilitating school improvement. The result is a volume that contributes on two fronts: on one hand to our growing understanding of how best to effect educational improvement in schools and, on the other, to our awareness of the importance of arts experiences in childhood and youth education.

It is this combination that makes Jane Remer's book special. There is a substantial body of literature in education and other fields on effecting change. There are also many treatises on the arts and their place in educational institutions. But books combining the two are virtually non-existent.

Remer's narrative moves in and out of a series of experiences with school districts seeking to place greater stress on the arts in education. I pass quickly over the various motivations involved. It is sufficient to say that responsible persons perceived in the arts opportunities to enhance

the education of children and youth. Top leadership in these districts perceived, also, the potential of using the arts as a vehicle for general school improvement. Jane uses these situations to enrich and illustrate her observations on what appeared to her to enhance school improvement through the arts. The result is an almost unprecedented illustration of principles drawn from research and theory but not often enough accessible to those who manage and teach in our schools.

The proposition that the arts are basic in the education of our young has been argued effectively in relatively recent books directed to both the general public[1] and educators.[2] All states make reference either to the arts or to the aesthetic development of children and youth in the guides they prepare for local school districts. And parents, it appears, want it all for their children when it comes to education—goals encompassing the arts as well as mathematics, language arts, science, social studies, physical education, and vocational education.[3] To provide only reading, writing, spelling, and arithmetic in schools is to ignore both a historical and a contemporary mandate.

Ms. Remer reiterates the familiar justifications. But she, like some others who believe in arts education, perceives the role of this domain as being much more than a designated subject or group of subjects. Because, for example, the arts in some form are always an accompaniment of what people in other times did or in other places do, they constitute a significant part of history and geography. They become not only a field in themselves but also an inseparable part of the rest of humankind's knowledge and skills. The arts, then, are not only a specialized field of study and performance but an integral part of general education for all. One does not argue for the need to understand civilization without implicitly arguing for the arts. This view pervades Remer's book and her reiteration of a fundamental premise is in itself a contribution.

[1] American Council for the Arts in Education/Arts, Education and American Panel. *Coming To Our Senses*. New York: McGraw-Hill Book Company, Inc., 1977.42

[2] Hausman, Jerome J., ed. *Arts and the Schools*. New York: McGraw-Hill Book Company, Inc., 1980.

[3] Findings from A Study of Schooling, a comprehensive look at a representative sample of schools in seven regions of the United States. For preliminary information regarding this Study, now in process, see Goodlad, John I., Kenneth A. Sirotnik, and Bette C. Overman. "An Overview of 'A Study of Schooling'," *Phi Delta Kappan*, 61, No. 3 (November, 1979), 174–78.

Her larger contribution, however, resides in the insight she provides regarding how to establish the arts in schools while simultaneously using them as a vehicle for school renewal. I deal with the second of these two processes first. In recent years, students of educational change and improvement have become increasingly aware of what are becoming known as "networking" strategies. Individuals and groups of present or potentially similar interests are linked together in ways designed to maximize commonality otherwise not likely to be joined and shared.

This is not a new technique but the history of its use in schooling is short. The elements are famliar. The units to be linked can be scattered geographically but share some common goal such as using the arts to look afresh at ways to rejuvenate schools grown staid through the preservation of long-established practices. Some central agency establishes itself as a hub. The hub simultaneously builds a bridge to each of the units to be linked and then promotes ways to link each unit to each of the others. Envision a wheel with spokes from the hub to each unit and a rim connecting the units. Begin to employ terms conveying family relatonships or common membership such as Family of Schools or League of Cities. Common expectations are conveyed.

Envision further the infusion of different and perhaps countervailing ideas into the whole. New and alternative drummers convey messages that differ from those dominating current practices. The alternative messages become the new norms. Those espousing the new norms become role models for persons who have similar beliefs but, perhaps, live in a daily environment not conducive to the cultivation of these beliefs. What were once somewhat countervailing and perhaps threatening beliefs become fashionable beliefs. One is able to believe differently without appearing bizarre. Ideas once considered provocative become ideas considred to be in vogue.

The above is a simplistic summary of the strategy of change employed by the individuals and institutions described in what follows. The organization with which Jane Remer and Kathryn Bloom—to whom the former gives great credit—were affiliated and which served as the "alternative drummer" was the JDR 3rd Fund in New York. The units with a spark of mutual concern seeking a catalyst were school districts from New York City to Seattle, Washington. These institutions and others came together for mutual satisfaction and accomplishment. Jane Remer describes the process and its effects.

The common enterprise was to make the arts more central in school programs and to improve school programs through the arts.

Usually, however, such enterprises ebb and flood. The arts have tended to remain peripheral in school programs in part because their teaching has been relegated to specialists. My own studies, referred to earlier, suggest that elementary school teachers, for example, do not feel as well prepared to teach the arts as they do language arts and social studies. Consequently, they welcome into their classrooms persons who claim specialization in arts education. The presence in schools of persons who take over from regular classroom teachers all responsibility for teaching the arts has certain negative consequences. Regular teachers do not feel a responsibility for the arts; the arts become special.

The approach recommended and described by Jane Remer moves the arts from a peripheral to a central place in the classroom. The classroom teacher and the arts specialist work together in making the former increasingly autonomous and self-dependent in arts education. Teaching the arts and infusing all other subjects with the arts becomes part of the repertoire of classroom teachers. A constituency for the arts is built inside of the schools.

Finally, let me say that Jane Remer's book is one of the few case studies available to us for increasing our understanding of processes of school improvement through a vehicle which itself is indigenous, not foreign, to schools. The arts for schools have been articulated and legitimated by all fifty states. But rhetoric is not enough. The strategies described in this book can help convert rhetoric to practice. But, more, they can help schools and school districts engage in that reconstruction of schooling which many of us are convinced is necessary to the very preservation of our unique society.

John I. Goodlad

ACKNOWLEDGMENTS

My profoundest thanks go to the Exxon Education Foundation and to the JDR 3rd Fund for their financial support of this project. In addition, but for the personal support of George Aguirre, Blanchette Rockefeller, Elizabeth McCormack, Porter McKeever, and Pat Lucas, this book might never have seen the light of day.

My deep and abiding gratitude also extends to Ted Berger and the late Arthur Kerr of the New York Foundation for the Arts; Tom Quinn, my editor at McGraw-Hill; Edythe Gaines and John Goodlad; the members of the League of Cities, and a host of friends and colleagues in the field.

To Camy Calve, my former assistant and secretary, my debt is immeasurable. Only she could have deciphered the maze of material known as my first draft and put it into legible shape.

My parents, Duds and David, and my children, Abby and Harry, are often my severest critics but among my staunchest friends. Their love and faith have sustained me through many dark passages and I feel lucky to have been blessed with such a family.

My respect for and gratitude to Kathryn Bloom are infinite. It was she who created an unparalleled opportunity for me to search for new ways to integrate the arts into the education of every child. During the six years that we worked together, her strength, vision, and unfailing sense of good humor taught me the true meaning and value of partnerships and mutual support.

Kathy was never afraid to break the mold or bend the rules. In the true spirit of the American pioneer, she kept clearing paths and taking chances. She believed that foundations should be "stalking horses," unafraid to test new ideas, win, lose or draw. While she admired the risk-takers and even the impulsive, she was always a hard taskmistress with her staff. You could speculate, experiment, and deviate all you wished, but you had better produce; the program's survival depended on it as did her faith in you.

She has been to me and to many others in the field an inspiration, an anchor, and a goad because she was never satisfied. Whatever had been accomplished and before we had had a chance to catch our breath, her question was always: What's next? "What's next" was usually just around the bend and Kathy had the uncanny and often unnerving ability to pick it up . . . and run with it.

Looking back at the events of the past two decades, one may be tempted to say, "They were giants in those days." Throughout her long and distinguished career, she was certainly one of them. In fact, if anyone deserves the title of "elder statesperson" in the arts in education movement, it is Kathryn Bloom.

CHANGING
SCHOOLS
THROUGH
THE ARTS

INTRODUCTION

The Promise of a Powerful Idea: All the Arts for All God's Children

> We need to expose *all* of the children in our schools to *all* of the arts, and to do so in a way that enriches the general curriculum rather than reinforcing the segregation of the arts.
>
> —John D. Rockefeller 3rd

All the arts for all God's children, not just the privileged few. It was originally Mr. Rockefeller's idea. It has since become a cause, a rallying cry for a growing number of people from all walks of life who have converted their commitment to this powerful idea into comprehensive arts in general education programs. These people recognize the value of the arts for their own sake and their usefulness as tools for teaching and learning. They also understand the catalytic effect the arts can have in the complex process of school change and development. These people include chief school administrators, school board members, principals, supervisors, classroom teachers, arts specialists, guidance counselors, librarians, school aides, volunteers, parents, artists, arts administrators, college and university professors, and of course, students.

This book is about the promise and power of the idea—the people and their programs. It is based largely on the individual and collective experience of six diverse urban school districts known as the League of Cities for the Arts in Education whose members are located in Hartford, Little Rock, Minneapolis, New York City, Seattle, and Winston-Salem. The book will describe and analyze a somewhat unorthodox educational effort that began in 1973 under the auspices of the John D. Rockefeller 3rd (JDR 3rd) Fund's Arts in Education Program which was founded in 1967. It will document the origin of the idea of school development through the arts, trace the history of the League, set forth and define the components of AGE (Arts in General Education) programs, and describe the main strategies devised or discovered to translate theory into daily practice. It will also identify some of the problems encountered, mention some of the lessons learned, and suggest areas for further study and action.

I write the book from my perspective as a practicing professional and from my point of view as an investigative reporter with a professed bias. My statements and interpretations of the facts may be corroborated

3

(or disputed) by those who wish to visit League sites, observe progams under way, and talk with the people involved.

For the record, I do not claim that the League's approach to the arts in education is the only one around nor do I think it has a "corner on the market." I do not even believe it is necessarily the easiest way to go. It is, however, the one that I know best, and I am convinced that it works— under certain conditions. It is based on the belief that schools and the people in them, especially principals and teachers, should define their own educational philosophy and shape their own destiny. Since they are held responsible for the consequences, they should have a say and, therefore, a stake in the action. Grass-roots involvement in planning, execution, and assessment of programs is key. So are networking, collaboration, and continuing rounds of negotiation and consensus in the decision-making process.

School development is not an altogether new idea and the arts are no strangers in the education of the young. What is new is that the arts—all of them—are being recognized by the League and others for the galvanizing role they can play in helping schools to help themselves.

What is also new is that League programs offer tangible proof of the flexibility and adaptability of the model process League members helped to invent. While they all have certain fundamental elements in common, the programs actually represent six unique variations on a theme. They have been designed in light of local conditions and constraints and reflect the important differences of size, structure, geographic location, socio-economic-ethnic mix, and historical and cultural tradition. They offer at least six examples for on-site study and many options from which to choose, either in whole or in part.

What is perhaps most significant is that League programs have managed to wed the content of the arts and the school development process to broader educational and social purposes. By so doing, they have devised strategies for strengthening the school system itself and improving its image and relationship with the general community. In these days of austerity budgets, social unrest, and virulent attacks from some quarters on public schooling, that is no mean feat.

On the Bias: A Bit of Personal History

Except for a few excursions into the law, French history and literature, and the business world, I have spent most of my professional life in the arts and education. As for the arts, I have studied, performed, created,

observed, taught, and administered them. I grew up in a family where they were considered vital to survival and a priority item on our floating agenda. The breakfast- and dinner-table conversations did not discriminate in terms of decibel level, passion, or intensity where politics, sports, or the arts were concerned. Once the bread and butter issues were disposed of and the topical issue of the day had been debated to a fare-thee-well, we always came back to the arts. We still do because, for us, the arts are basic.

To a great extent, I took the importance of the arts for granted because my parents did. When some twenty years ago I had my own children, I assumed that they, too, would grow up taking the arts for granted. They went through the New York City public schools and as early as kindergarten, I began to look for the arts in the school program. In the beginning, I found precious little. While I knew that ultimately my son and daughter would not suffer because of what my family refers to as the "hidden curriculum" of home and background, I had three reactions. First, I felt as a citizen, taxpayer, and parent that the schools owed my kids more than just the three R's. Second, although we lived in Manhattan and were surrounded by arts and cultural institutions of all sizes and descriptions, most of them at that time kept their distance from the public schools. Third, it seemed downright unfair that my children should have all the advantages of the arts and culture simply because their parents happened to care and could afford them. I was concerned about their less fortunate classmates who might possibly not experience them unless the schools, the community, and the arts institutions made a concerted effort to do something about it.

The Purpose of This Book

For the last fifteen years or so, I have worked in and with schools, arts organizations, foundations, public education agencies and others trying to do something about the arts and education. This book is intended as another step in that direction. When the Fund's Arts in Education Program was terminated in August 1979, the League experiment was just beginning to yield promising results. I realized that if I did not try to document our work, some important information might never be shared with a wider audience. With the encouragement and backing of the Exxon Education Foundation, the JDR 3rd Fund, the New York Foundation for the Arts, McGraw-Hill, and League members, I decided to undertake the project. My purpose was to:

1. Set the record straight about the contribution made by the League, the Fund, and many others to the idea of school change and development through the arts

2. Pay tribute to some of the major and seminal thinkers, dreamers, and doers in the field

3. Be specific about some of the "how tos," providing guidelines, criteria, distinguishing characteristics, and some broad generalizations for interested "others"

4. Strike a blow in defense of the American system of universal public education, compulsory notwithstanding, because it has been maligned for decades mostly by those who do not understand it, work with it, or send their children to its schools.

Belling the Cat: What Is AGE?

> AGE is a concept, an instructional framework and a psychological contract.
>
> —Paul Hoerlein, Administrator
> Seattle Public Schools

> If I could *tell* you what I mean, there would be no point in dancing.
>
> —Isadora Duncan

People keep asking for a one-line definition of AGE. They insist they know more about what it is not than what it is. Many, especially those of us who have been busy doing it for nearly a decade, have been stumped for an easy answer. Ask ten different principals, for example, and you'll get ten different responses. To say that it stands for an Arts in General Education program which has a set of guidelines and criteria for planning and development is accurate, but it begs the question. To add that it proceeds from the belief that the arts are basic to a quality education and that ideally all children should experience all of them is fine, but still vague. It is time for me to try to bell the cat.

AGE is not a body of knowledge, a discipline, or a subject. It is not a textbook, a road map, or a box of instructional materials. It is not an in-service course, an aesthetic doctrine, or a teacher's manual. It is not a curriculum bulletin, an artist residency, or a "hands-on" workshop

experience. It is not bottled, canned, boxed, and available at a discount from your local supermarket.

AGE is a concept, a philosophy, a way of looking at schooling and the arts in order to alter teaching and learning generally. It is a set of ideas, a process, and a program. It is also an attitude, an abstraction which can materialize in different ways and in different forms at various times for various people. It goes by many names (e.g., Arts for Learning, Arts in the Basic Curriculum, Arts in Basic Education), and has several acronyms, but it has certain common qualities, elements, and characteristics.

AGE is a collaborative effort that relies on hooking up, or networking. It means that people plan and work together, share ideas, information, and resources, and make connections. It is a holistic or comprehensive way of dealing with a school and its community by studying the institution's structure and operational patterns and figuring out how the arts and artists can become more prominent, more pervasive, and more useful in the education of the young.

Paradoxically, AGE can be called populist, elitist, and pragmatic. It combines the notion of all the arts for everyone with the conviction that the arts have value for their own sake as well as for reaching other desirable ends. But AGE is primarily a grass-roots approach. It focuses on schools, classrooms, principals, teachers, artists, and students. It offers people in the schools a way of re-examining educational tradition, practice, and mandates in order to revamp the *status quo*. It also offers them another route to self-renewal because the arts stimulate and nurture insight, creativity, pride, and a sense of joy. And because the arts can be fun, AGE contributes to a general sense of well-being.

AGE, then, is fundamentally a way to change or develop schools through the arts. But in AGE, unlike some school improvement efforts, change is planned and brought about by the schools themselves; it is not imposed bureaucratically from the top down.

Perhaps, after all is said and done, the best one-line definition is: AGE, like beauty, is in the eye of the beholder. You probably have to see it to believe it. Definitions are useful, but I suspect that this may be one of those cases where seeing is believing and doing leads to understanding.

NEW YORK CITY: BIRTHPLACE OF THE CONCEPT OF SCHOOL DEVELOPMENT THROUGH THE ARTS

Balancing the Equation: Edythe Gaines and the Learning Cooperative

In the fall of 1972, I joined the New York City school system's Learning Cooperative. Having worked for so many years with the schools as an "outsider" in, for example, Young Audiences and the Lincoln Center Education Department, I felt it was time to learn more about schooling and the educative process from the inside, warts and all. I also wanted to balance my arts and education experience equation, which until then was heavily weighted on the former and somewhat slim on the latter. I felt that a greater intimacy with the school system would perhaps enable me, among other things, to unravel some solutions to the stubbornly persistent and often frustrating problems that confronted artists and educators when they attempted to work together.

My job at the "Coop" was to design and coordinate an Urban Resources Linkage Prototype. Translated that meant I was to devise ways to utilize the sites and resources of the financial, business, and cultural institutions clustered around Federal Hall in Lower Manhattan as the basis for instructional services to the schools. In addition, I served as a special assistant to the Coop's director, Dr. Edythe J. Gaines, a dynamic and visionary educator who had come up through the ranks as teacher, principal, and community superintendent. Edythe had developed a well-deserved reputation as an innovator and a strong advocate for the arts. Although my primary responsibility was the design and coordination of the Urban Resources Program (into which I determinedly wove the arts and artists), I spent a great deal of time consulting with her and the staff on arts-related matters.

I credit Edythe, her executive assistant, Nola Whiteman, and the rest of the small, devoted Coop staff with giving me an insight into the practical and political aspects of public education and bureaucracy that no book and no university could ever hope to duplicate. Our meetings were often stormy, intense, and serious; no idea, regardless of its origin or surface merit, was taken on faith, and "experiment" was considered a censorable word. In the crucible of the Coop we learned, among other things, the difference between "glamor stock," "scatter-shot" approaches and those that, when sound and sustained, would make a positive contribution to schooling. We learned about the art of creative money management in a sprawling public institution that is essentially labor intensive with little discretionary leeway. We also learned tolerance and respect for minority or dissenting opinions and how to achieve

11

collaboration, if not harmony, through negotiation and consensus. Our mission was to serve the field, not individual egos, and the bottom line—the acid test—was the benefit to kids.

But for that year at the Coop and the collegial relationship that sprang up, somewhat serendipitously, among Edythe, her staff, Kathy Bloom, and myself, the New York City AGE program and ultimately the League of Cities would probably never have been born. AGE was the product of a marriage of like minds and spirits in the Fund's Arts in Education Program and the Coop, both of which no longer exist. The Fund's history and legacy have been documented elsewhere;* the influence of the Coop and especially its direct and indirect impact on the notion of constructive school change and development through the arts deserves attention here.

Solving the Problem of "Bigness": Networking and Collaboration

The Learning Cooperative was established in 1971 as an arm of Chancellor Harvey Scribner's office. Supported by relatively modest public and private funds, its official function was to assist in the school decentralization process and provide services to the field. It was expected to identify successful programs and help foster innovative efforts by bringing together various educational, cultural, municipal, business, and private groups "to recreate excellence in the city's public schools."

As I have often observed, New York is not just another city but another country and the Coop's charge was immense if not overwhelming. Its task was to serve, directly or indirectly, over nine hundred schools, more than one million students, and approximately sixty thousand teachers and supervisors. The job was further complicated by the newly organized system of dual governance which placed responsibility for the senior high schools and certain special services at the Central Board and for the elementary, intermediate, and junior high schools in thirty-two quasi-independent community school districts located throughout the five boroughs.

Faced with the question of how a small staff could "take on" the whole system, the solution proposed was to consider the Coop a hub of several separate but functionally related networks. In other words, to

* *An Arts in Education Source Book: A View from the JDR 3rd Fund*, New York, 1980.

solve the problem of "bigness," smaller identifiable groups would be organized, linked together with appropriate community resources and provided with consulting, technical, and fund-raising assistance. In addition, a few program prototypes would be designed to field-test new ideas, and results would be shared with practitioners and the community at citywide dissemination conferences. Demonstration and other exemplary programs and practices would be documented and made available for inspection in the field.

Design for Change: The Arts in General Education (AGE) Manifesto

"Design for Change," a Special Supplement to the New York City Public Schools' *Staff Bulletin* (May 15, 1972) is a relatively little-known four-page document that described the mission of the Coop and outlined the concepts of total school development and comprehensive systemwide change. "Design" provided the conceptual framework for the Urban Resources Program and later became the "manifesto" for AGE. Its main ideas were ultimately adopted and further refined by the League of Cities. Its influence now extends to other school districts and state education departments which have absorbed some of the basic tenets into their arts in education programs.

"Design," although cooperatively authored, was essentially Edythe's brainchild. The core of its philosophy may be summed up as follows:

> The new educational system is a network of interrelated and interacting component parts of which the core school is a key part. The core school is one in which a pupil is enrolled and accounted for, where he spends a significant amount of time, where he is assisted with "brokering" the other parts of the education network, and where he is provided with certain foundational learning (e.g., basic literacy).

As stated earlier, key concepts in this document were program prototypes, demonstration ("beacon light") schools, networks, linkages between schools and the community's resources, an on-going leadership and staff development effort, an information and feedback system, and citywide dissemination conferences. Basic to these concepts was a

strong belief in individualized and humanized education, choice of teaching and learning style, and environment and education as an integrated process. Parent and community involvement in schooling was viewed as a means of increasing public support and broadening the range of instructional opportunities for students and teachers.

"Design" did not attempt to foretell or prescribe specific programs, educational support services, or even a master strategy for systemwide overhaul. It was intended as a credo, and it was hoped that practitioners would convert ideas and beliefs into effective practice. It did, however, spell out one central strategy:

> Change is never comfortable and therefore is rarely welcomed. Quite the contrary. Usually it is resisted either overtly or covertly. Consequently, change will not occur unless it is deliberately planned for. We plan to include in each program or proposal a specific mechanism whose function it is to set in motion a specific set of strategies by which the changes we are aiming for are likely to be brought about. . . . That is the revolution we seek!

"All the Arts for All the Children," A Joint Venture between the New York City Public Schools and the JDR 3rd Fund

By June 1973, when I joined the Fund's Arts in Education Program, Edythe had become Executive Director of the school system's newly formed Division of Education Planning and Support, with the Learning Cooperative as its operational arm. Banking on her long-standing advocacy of the arts in education, Kathy and I proposed a collaborative project to be launched in the city's schools. Once we agreed on the general nature and purpose of our joint venture, Edythe asked me to prepare a position paper and a comprehensive plan of action.

The New York City plan was developed in consultation with key personnel from the Central Board, the local school districts, the schools, and the arts and cultural community. It included the basic tenets outlined in "Design for Change" and built on the Fund's six-year experience with comprehensive pilot projects. It incorporated the lessons learned from the Fund's work with the Bank Street College of Education and a few of the city's elementary schools, notably P.S. 51 and P.S. 3 in

Manhattan. It also took into account the strengths and limitations inherent in the nation's largest school system and the realities of contemporary urban life: fiscal crises, racial and ethnic diversity, union power, and a complex set of bureaucratic agencies and procedures.

The plan laid out the goals, characteristics, and processes for school development through the arts. It did not prescribe a specific instructional program, a curriculum development, or teacher-training effort nor did it promise large amounts of incentive money to potential participants. School programs were to be developed by the participants, themselves, mainly using existing resources and relying heavily on the strategies of networking and collaboration.

The materials prepared included:

- A rationale for the arts in general education
- A description of the characteristics of effective arts in general education programs at the school and district levels
- Criteria for elementary and secondary school participation in the program and guidelines for the selection process

They also provided:

- Criteria for the effective use of cultural resources and artists in the schools and the community.
- Strategies for the formation of a network of demonstration, cooperating, and consultative schools.
- A general description of the school development process.
- A definition of the roles, functions, and responsibilities of all participants.
- A statement that the main source of funds for the program would come from existing central and local school budgets. In lieu of a major grant, the Fund's main contribution would be to provide technical, consulting, and management assistance and small amounts of seed money for planning and development. (It should be noted that although the plan operated on the theory of a zero-based budget at the outset, a substantial amount of school district and outside funds for planning, leadership training, staff development, and artist services were soon identified and secured.)

Although the program was to be launched in a relatively few schools in largely uncharted waters, it was hoped that in time an arts in general education school-development prototype would emerge that could apply to a large number of local schools and school districts and perhaps to other school systems around the country.

What made the New York City AGE program unique was Edythe's decision to join with the Fund to determine whether and how the arts could become the organizing principle and the instructional framework for overall school improvement. The Coop's Beacon Light School network left the choice of philosophical goal and the strategies for achieving it up to each school. In the AGE program, however, the goal was explicit: "All the arts for all the children," and those superintendents, principals, staff, union representatives, parents, and student leaders that wished to work together toward this end were invited to stand up and declare themselves. Some of the most unusual characteristics of the partnership are described in a paper I wrote a few years ago:

> While a review of the original position papers, working documents, and rationale for New York City's AGE program reveals the important legacy of the Fund's prior experience, the New York City program marked a turning point because it was unique in several significant ways:

> 1. For the first time, the Fund and a major urban school system officially agreed to become partners in the planning and development of a comprehensive arts in general education program. This partnership was established through an exchange of correspondence that clearly defined commitments, roles, and functions.

> 2. Defying philanthropic tradition and establishing a precedent for the Fund's future work, no major grant was awarded to the school district and no specific time frame was mentioned. Instead, we mainly provided technical and consulting assistance and participated actively in every phase of the program from conceptualization to the design of plans and strategies for management, implementation, documentation, and dissemination. This was also the first

time that a staff member of the Fund was involved in the day-to-day operation of a program from the beginning.

3. The arts and the AGE program in particular were to be used to discover whether or not and in what ways schools could develop and improve themselves by working in concert with other schools and with the support of an array of agencies, organizations, and people within and outside the system. The hypothesis to be tested was, How can an AGE program and the AGE approach to change—where the arts are used as content, as tools for interdisciplinary teaching and learning, and as vehicles and catalysts for innovation—galvanize the process of total school development and result in better schooling for children and youth?

4. In the Fund's earlier projects, the development of programs placed primary emphasis on teacher training, curriculum development, and the involvement of artists and artist-teachers. In AGE, these elements were considered important as program components and as support systems, but *the goal was and is school development through the arts.* The idea was to integrate the arts into the teaching and learning process and thereby alter the entire climate and operation of the school.

5. The emphasis on an organized approach to school change was perhaps the most unique aspect of New York City's AGE program. Through networking and collaboration, basic and cost-effective strategies, the goal was to develop prototypes that would be available for inspection and generate documentary evidence of a model process for other schools and school districts to study and adopt if they wished.

The Goal, the Five Main Characteristics, the Change Theory, and the Process for Achieving It through AGE

The goal of AGE is contained in its program subtitle, "All the Arts for All the Children," and was more specifically defined in the original plan as follows:

To improve the quality of education for all children by incorporating all the arts into the daily teaching and learning process. . . .

The five main characteristics of AGE which were to be translated into comprehensive programs and instructional activities were spelled out as follows:

- Interdisciplinary teaching and learning situations where the arts are related to each other and to other areas of the curriculum

- High-quality instructional opportunities in each art form for all students

- Effective use of the community's arts, and cultural resources, in and out of school

- Special programs in the arts for children with special needs (e.g., the gifted and talented, the handicapped, the educationally disadvantaged, the multilingual)

- Use of the arts, artists, and arts organization services to reduce the damaging effects of personal and racial isolation

The theory for school change and development through the arts and the process by which the system was to help bring it about were then summarized as follows:

- The individual school is the most efficient, manageable, and logical social unit for educational change.

- The principal is the educational as well as the administrative leader of the school community and can effect fundamental, positive changes in schooling by regularly involving supervisors, teachers, parents, and students in the decision-making process and the implementation of school programs.

- Change is difficult, especially if the alternatives proposed deviate substantially from the prevailing norm. Thus, schools cannot and should not go this route alone since they need the support of other schools, the community district, the central board, and other public and private agencies and organizations outside the school system.

- All schools in the system are notified of a new program opportunity, given guidelines and criteria for participation, and invited to submit proposals. Screening committees review proposals, visit

schools, and gather relevant information. Schools are ranked and selected for participation based primarily on broad school-community commitment to program purpose and the actual or potential ability to carry out program intent.

- Citywide and/or districtwide networks of "like-minded" schools are formed for mutual support, problem solving, and the sharing of information and resources.

- These networks of principals, supervisors, and teachers are co-ordinated by a "hub" or management team which provides technical and consulting assistance, orchestrates support services, and identifies and secures the human, financial, and physical resources which the schools have determined are essential to progress.

- Over time, these networks serve as tangible demonstrations of a particular idea or concept translated into effective practice. They provide a talent bank of authentic resource professionals and a source from which information about their experience in leadership training; staff, curriculum, and child development; school reorganization; community relations and fund raising can be captured and shared with a wider audience.

- Ideally, demonstration networks increase their membership so that they become large enough to notice but still small enough to manage. Members also participate in other coalitions that have similar purposes or help to form affiliated networks that establish functional relationships with the core group and its hub.

- Expansion of the original network and linkages with others eventually create a "critical mass" of schools that inspire and help still more schools to follow their example. Given the right encouragement, recognition, and support, a significant number of schools in a system will improve the nature and quality of educational opportunities they provide for all their students.

Planning the Program: The Dry Martini Formula

Planning for the AGE program began in July 1973. The joint venture was formally announced in May 1974; schools were identified by January 1975, and full-fledged activity in the schools began in the school year 1975–76. In effect a full year and a half had been spent by a great many people on a variety of preparatory and training activities long

before the program became operational and school-based. To be sure, the size and complexity of the school system contributed to the amount of time and energy consumed in the process, but so did the nature of the process itself. On the basis of past experience, we were determined not to do things "quick and dirty" but to use time as an agent in creating public awareness, involvement, and support. Our methods and patience proved rewarding and later led me to counsel my colleagues in the League and elsewhere that the formula for any program's "success" was the same as for a very dry martini: five parts gin (planning) to one part vermouth (operation).

There were essentially four stages in the planning process. The first nine months were spent drafting the position paper, designing the comprehensive plan, and organizing a "Project Management Team" consisting of Coop staff and myself.

The second nine months concentrated on leadership-training activities and seminars for members of the Central Board and the Learning Cooperative; the development of guidelines and criteria for participation in the project, and the identification of schools and community resources. During this period, consultants such as John Goodlad, Robert Stake, and Stanley Madeja were among those who participated in "think tanks" at the Coop. Members of the Coop's staff also visited the CEMREL (Central Midwestern Regional Educational Laboratory) laboratory in St. Louis and JDR 3rd Fund project sites in University City, Missouri, and Oklahoma City, Oklahoma. Costs for consultants and site visits were underwritten by the Fund.

The next six months were devoted to school-staff orientation and organization of the network. During this period, the principals and AGE planning teams from each of the schools identified their needs and resources, decided on their program objectives and strategies for implementation, and revised their budgets accordingly. Regular network meetings were held and representatives from the city's arts and cultural institutions were invited to cooperate in planning certain aspects of the school's programs.

Main Features of the School Identification Process

Recognizing the complexity of the AGE program, we were often tempted to pick the principals we all thought we could count on as winners. AGE was, after all, a demonstration program, not a turn-

around or compensatory effort, and we were under no obligation to satisfy federal guidelines or deal with standard bureaucratic red tape. After weighing all the pros and cons, however, we decided it would be wisest to "go public." Consequently, a formal announcement of the program was made at the Central Board; all schools were sent guidelines and criteria and invited to submit brief "proposals" (which were actually declarations of intent), and an orientation meeting was held for those who wished to learn more about the specifics of our plan. Our reasoning for going public was that participation in this unusual venture, whether by school people, artists, or other community representatives, should be voluntary and reflect a broad and genuine commitment to the program's overall philosophy and purpose. We knew from past experience that programs and expensive package deals imposed on schools rarely take root because they generally bypass the very people on whom "success" depends.

network building / professionalism

Final recommendations for the AGE school network and the classification of schools within that group were based on four main sources of information: simple written proposals and supporting materials, site visits to the schools, firsthand knowledge and experience of the Project Management Team and an ad-hoc Steering Committee, and the advice from members of the teachers' and supervisors' organizations and others familiar with the schools and the program's objectives.

The first step in the screening process was the review and ranking of the thirty-two written proposals which had been submitted. Each proposal was read by the Project Management Team and by at least three members of the Screening Committee, and each Committee member reviewed a minimum of three proposals. Proposals were checked to determine whether they met the guidelines and were then ranked on a prepared form listing program criteria. Written comments were added where appropriate. This "raw data" was then transferred onto a profile sheet for each school.

Site visits to those schools which met the project guidelines for "demonstration" status (elementary, intermediate, or junior high schools in districts with more than one school applying) were then arranged for members of the Project Management Team and the Screening Committee. Since the "raw scores" for the proposals from all thirty-two schools were unusually high (none fell below the median level), it was decided that single schools from a district or from the Senior High School Division would automatically be eligible for either "cooperating" or "consultative" status.

Checklists based on the same criteria used for proposal ranking

were also prepared for site visits. The observer teams were given instructions regarding what to look for and inquire about in the contending schools and again asked to rank each school according to the items on the list. These sheets were then compiled into school-site-visit profiles and the "raw scores" were added to the original profile sheets. The Project Management Team's recommendations for the AGE network were endorsed by the Screening Committee and subsequently approved by Edythe. *All thirty-two schools were accepted.*

Original Categories of Schools in the AGE Network

When AGE began, the thirty-two schools were arranged in three interconnecting networks. As the program developed, we found this structure to be impractical and unrealistic. Eventually, after several reorganizations, all schools were absorbed into one group as "demonstrations" with the understanding that each was in a different stage of, as we called it, "the process of becoming." For the record, however, here is how we began.

Demonstration Schools

Demonstration schools receive intensive technical assistance in all areas of program planning and development. They are the first in line for leadership training and other staff and curriculum development activities, modest financial support, and for dissemination of program results. They participate in monthly network meetings, serve on committees and task forces, and assist in documentation, dissemination, and evaluation. Principals and staff are available as consultants, and their schools are open for observation and study.

Cooperating Schools

Cooperating schools receive less intense but high-quality technical assistance in program planning and development. They participate in many of the planning activities and training sessions scheduled by and for demonstration schools and receive regular information about program progress through the network. They are the second in line for dissemination of program results and receive modest financial support.

Consultative Schools

Consultative schools have a supportive and advisory role in the Project. They provide technical assistance to other Project schools and have the

opportunity to participate in a variety of program and staff-development activities.

Criteria for Participation in AGE

For those interested in the nitty-gritty of the selection process, following are the criteria we originally established for program participation. They have since served as guidelines for many school districts nationwide, including the League of Cities.

A. Checklist of Criteria for Review of School Proposals

1. Quantity, quality, variety, and general availability of existing arts programs
2. Plans for improving and expanding existing arts programs and for incorporating all the arts into the general education program for all students
3. Evidence of or plans for an interdisciplinary teaching and learning approach
4. Identification and use of existing, in-house resources indicated in these plans
5. Identification and use of community resources, especially arts and cultural
6. Evidence of effective school leadership
7. Evidence of staff involvement in school programming and project planning and development
8. Extent and nature of district and community awareness of, and commitment to, the school and the project
9. Capability of school and district to implement plans and programs
10. Other strengths or weaknesses (written comment)

B. Checklist of Criteria for School Site Visits

1. General impression of the school climate and environment
2. Level of openness and receptivity of the school to the visitor/ observer
3. Use of existing space, materials, and equipment for current programs
4. Quantity and quality of existing arts programs
5. Quantity and quality of interdisciplinary programs
6. Extent of the school's involvement with community resources, especially arts and cultural

7. Extent and nature of general student-body participation in arts and interdisciplinary programs and cultural events
8. Familiarity of the principal with the program's goal, objectives, strategies for implementation, evaluation, and dissemination
9. Familiarity of school staff with the program
10. Extent of district and community support of the school and the project
11. Extent of parent and community involvement in the school
12. Other strengths or weaknesses (written comment)

C. Other Things to Look for When Visiting a Potential School or When Gathering Related Information from Reliable Sources

1. The nature and scope of the school's commitment to the idea of educational change through the arts and to participation in the program as evidenced by the school administration, staff, and parents. Superficial familiarity with the program is not sufficient.
2. Nature and degree of involvement of the school staff and parents in the proposal-writing processs. If the principal is the only one who has been responsible for the proposal, without the advice and consent of his or her staff, prospects for total school involvement and support of the program are dim.
3. The style and effectiveness of the principal as an educational leader and an able administrator. Evidence of teamwork and participation of the staff and parents in the decision-making and evaluation process is important.
4. The attitude of the staff toward the principal, each other, parents, and especially the children. Openness, respect, warmth, and courtesy are important qualitites to identify.
5. The general tone, energy, and atmosphere of the school as a pleasant, attractive, and exciting place in which to live and learn. If the school is dark, the walls and classrooms are barren, or if it gives the impression of a rigid, stratified society, prospects for success are minimal in a program which requires collaboration, flexibility, and creativity.
6. General enthusiasm, even impatience, to participate in the program and candid recognition of areas of need in which technical and other assistance would be useful.
7. Evidence of open lines of communication throughout the school and its community.
8. The kind and quality of teaching and learning taking place in

the classroom. Children should look actively involved in what they are doing and at ease with their peers, teachers, visitors, and surroundings.

9. Evidence of a wide variety of teaching and learning styles and program choices in the school.

10. Evidence of the arts and creativity in the halls, the classrooms, and throughout the school; presence of artists in residence and other community resource personnel.

11. Evidence of untapped resources in the school and community with potential for program development. Many schools do not always recognize or use most effectively the human talent and other resources that exist in their own environment and in their immediate neighborhood.

12. Evidence of on-going staff and curriculum development programs and activities.

13. Use of existing space and facilities for learning and resource centers, labs, and parent and teacher conference rooms. A well-stocked, colorful, and well-used library is also significant.

14. Potential areas of trouble such as lack of school-board and community support, teacher-union difficulties, inflexible schedules, conflicting priorities and educational objectives.

15. Depth of understanding of potential importance the arts have for improving the quality of education for all children as evidenced by discussion of the project as a school-development effort, not a cultural-enrichment or arts-exposure program.

16. General capability of the school to design, implement, and evaluate the plans, programs, and activities described in their proposal.

Outcomes of the Citywide School-Identification Process

The school-identification process took four months and consumed the time and energy of a large number of people from the school system and the community. In the end, it turned out to be well worth the investment and produced some unexpected results.

The original AGE plan called for four demonstration schools from two districts (a pair in each district) and an unspecified number of cooperating schools. The decision to accept thirty-two schools was

based largely on Edythe's confidence in the Project Management Team's ability to assume increased administrative responsibility. It was also made in recognition of other factors such as the high quality of leadership, support, and commitment from the schools and the community that kept surfacing during the selection process.

Another reason for the decision resulted from our happy but not too surprising discovery that much of what the program was hoping to achieve in the next few years was already happening in pockets of a number of the city's schools. What was primarily needed was a more comprehensive and systematic approach to total school development so that existing programs and services would become more sophisticated and reach all the students at all grade levels.

Perhaps the most influential reason for enlarging the network grew out of the realization that we needed a broader base of community awareness and support for the novel idea of school change through the arts. The original plan was based on the conviction that programs of this kind, which call for fundamental modifications of attitudes and behavior, should start small, be carefully nurtured, and be permitted to grow gradually and organically. The theory was sound but did not take into account that "small" is a relative term and, in a city the size of New York, four schools are almost invisible. In addition, a larger field would provide more options for others to study and choose from.

Therefore, we modified our plans and organized a network of thirty-two "demonstration," "cooperating," and "consultative" schools representing thirteen of the city's thirty-two community districts and the Senior High School Division. This network was large enough to notice but still small enough to manage and had the additional advantage of broad geographical, socioeconomic, racial, and ethnic diversity and balance—critical considerations in New York City and any other urban center.

There were other important outcomes of the citywide selection process:

- First, as many as thirty-two schools, a few of which were unknown to us, were apparently willing to make a serious and, if you will, somewhat blind commitment to the abstract notion of school development through the arts, despite the fact that there was no ready-made program to install and no large sums of money or additional personnel were being dangled as incentives. The extent and nature of this commitment was all the more

impressive because it was backed up by superintendents, school-board chairpersons, teacher-union representatives, PTA presidents, and heads of student governments, all of whom were required to join the principal in signing off on the proposals.

- Second, as word spread about the program, an increasing number of public and private philanthropical organizations and other community agencies made commitments to it because a few thought it was a coherent approach to school improvement, some saw it as another source of advocacy for the arts, and everyone felt that at last they would be able to "get through the maze at the Board of Ed" and perhaps have an impact on not just one or two isolated schools but on an organized, visible group.

- Finally, through constant dialogue and exchange of information among the Project Management Team, the divisions and bureaus at Central, the community districts, the schools, the arts and cultural resources, and the Fund, an informal communication network was established which helped sustain the program in its early days and contributed to its ultimate survival.

Biting the Bullet: A Bloodless "Revolution" with the Arts as the Instruments of Change

I have a number of friends in the arts world and a few in the field of education who agree that the arts should be studied for their own intrinsic value but who wince every time I refer to the arts as tools, catalysts, agents, or instruments for school change. I think three things bother them: first, they believe the arts are somehow sacred and not to be tampered with; if the arts are used for other purposes, especially social ends, they will be bastardized and distorted beyond recognition. I, for one, do not consider the arts or artists so fragile and vulnerable, and fortunately the last nine or more years have proved me right for the most part.

Second, the notion that *all* the arts are or should be the province of *all* the children threatens not only the patrician definition of what is "fine" or "high" aesthetically, but adds insult to injury by maintaining that the arts are within everyone's reach. Arts for the people is a populist but still not very popular idea.

The third reason underlies the first two: the arts for change implies an erosion of or an attack on the status quo, and this danger, imminent

or far off, real or imagined, is enough to unsettle most people, myself included, who instinctively prefer to cling to the security of *what is* rather than take too many risks for the sake of *what might be*. Probing the unknown may produce rewards; it can also unleash anxiety and upheaval.

Edythe, Kathy, and I did a lot of talking about this in the early days. We somehow sensed that we had gotten hold of a not-so-paper tiger by the tail and were probably starting a small, albeit bloodless, revolution such as the one called for in "Design for Change." I do not mean to sound grandiose or melodramatic, but changing schools means by definition changing people. Since most people resist change "unless," as "Design" maintained, "it is deliberately planned for" by the people who will effect and be affected by the process, the prospect of it will not be welcomed and its course will be blunted. Although we had built the concepts of ownership and cooperative action into the plan, we really weren't sure whether all the bases were covered. We also wondered how the "powers that be" would react to a cluster of schools taking charge of their own destiny.

In brief, planning the program, identifying and corralling resources, and selecting schools had been challenging and time-consuming but relatively painless. Our ideas were attractive but largely theoretical, and our language was sometimes numbingly rhetorical. When it finally came time to test our unorthodox approach in the schools, it became clear that we were in for a long, hard journey. But Edythe kept urging everyone to "bite the bullet" and proceed undaunted on our joint "adventure." Kathy, a born rebel, agreed; she maintained we had everything to learn and nothing to lose except a few hours of sleep at night. That was a small price to pay for discovery.

Nine, five, or even as little as three years ago, I could not have written this book. A great many people around the country have had to go through and often invent parts of the process in order to make it tangible—for them, for me, and I hope for you. My hat is off to all those out there who "bit the bullet" and used the arts as ammunition for better schools.

GUIDELINES FOR AGE PROGRAMS: THE LEAGUE'S PROCESS MODEL

Considerations for School Systems Interested in AGE Programs

The New York City AGE program began in 1973. By 1976—three short years later—five additional school districts had joined forces with the Fund and decided to form the League of Cities for the Arts in Education. In essence, Hartford, Little Rock, Minneapolis, Seattle, and Winston-Salem learned of the approach being developed in New York and decided it was one worth pursuing in their own school systems. I shall have more to say about the formation and operation of the League in a later chapter. It now seems appropriate to set forth an outline of the process by which League members established, maintained, and expanded their individual efforts.

News about the League had spread quickly, and the Fund was soon deluged with requests for information and participation. Although we were in no position financially to expand the League, per se, we had an obligation to make information about the network available to others. By September 1977, I felt there was enough concrete evidence and experience from which to generalize. If we couldn't enlarge the network or even provide from our own collective ranks all the "hands-on" consulting and technical assistance that was being demanded, we could at least try to put something in writing that would offer a framework for planning and development. While I knew in my heart that written materials of this nature are no substitute for face-to-face, on-site encounters, a short practical document might at least define a starting point for our growing audience.

What people seemed to want was a rationale, a definition, and a plan of action. This chapter deals not so much with the "why" and the "what" as with the "how to." It is essentially a composite based on the League's experience, a "model process" or "process model." It does not prescribe a formula for program content nor a strictly linear and sequential approach but instead sets forth the concept, elements, strategies, and some questions that any school or school system might wish to consider before and after embarking on an AGE program.

What follows is an updated version of the paper I wrote in 1977 under the unwieldy title of "Considerations for School Systems Contemplating a Comprehensive AGE Program."* Some portions of it may sound familiar, but I feel they bear repeating in this new context.

* Reprinted by permission, The JDR 3rd Fund ©1980.

31

The Concept and the Process

The basic conviction that underlies all League progams is that all the arts are integral to the education of all children because they can make an important contribution to the daily schooling process, kindergarten through high school, throughout entire school systems.

The hypothesis being tested is that the quality of education and equality of educational opportunity can improve when:

1. The arts are related to each other and to other disciplines
2. Quality programs in all the arts are available to students
3. The community's artists and its arts and cultural resources are used regularly in and out of the school building
4. Special needs of special children (the gifted and talented, the handicapped, the bilingual) are met by the arts and through participation in creative activities
5. The arts are used to create learning situations which help reduce personal and racial isolation and increase self-esteem

This hypothesis is both fluid and flexible. The above five points often appear as the main objectives or characteristics of League programs in proposals for funding or other descriptive materials.

The strategies being devised to test this hypothesis are derived from a theory of educational change which regards the individual school as the most effective social unit for self-renewal because it is the smallest, yet most complete setting in which formal schooling takes place on a continuum. According to this theory, the principal can be both a creative educational leader and an effective social engineer when he or she works closely with staff, children, parents, and community on programs that gradually and systematically translate the school's educational philosophy into daily reality. It is assumed that when those who have a stake in the consequences reach important decisions through a continuing round of dialogue, decision making, action, and evaluation of issues and problems, benefits can accrue to the total school community and especially the children.

Schools, however, cannot go it alone if they wish to make fundamental, comprehensive, and enduring changes in their structure and operation. They need the support of other schools, the school district, the community, and other local, state, and national resources. The means for securing this support is through collaborative action.

Thus, a network of schools committed to the same philosophical approach is formed. This network is supported by a "hub" (a person or a team of people) that coordinates its activities, seeks out and secures needed resources, and provides technical and consulting assistance.

Under Certain Conditions

Experience with the League and with other comprehensive arts in education programs reveals the circumstances under which programs of this nature develop, thrive, and survive. Following are a series of questions which might be asked before a school system decides to start a program. It is also useful to refer to them periodically during the planning, development, and expansion process in order to determine the rate and nature of progress being made.

1. Are the school system and the community relatively stable and yet resilient enough to respond to change?

2. Is there (or is there likely to be) evidence of continuing top-level leadership and support for the concept of a comprehensive arts in general education program?

3. Can support be generated from parents, the arts and education communities, volunteer and civic groups, unions, professional associations, business and industry, local and state legislators?

4. Is the notion of partnerships—to plan, implement, fund— accepted by those who will be involved?

5. Have there been discussions with administrators, supervisors, principals, teachers, arts specialists, artists, heads of arts organizations and agencies, etc., in order to make clear that the arts in general education concept provides a framework for a comprehensive educational approach and is not a special arts program, an artists' residency, a cultural enrichment series, or a remedial effort?

6. Have potential sources of planning and development funds been explored at the local, state, and federal level? Is it clearly understood that "outside" funds are used mainly for special programmatic or developmental purposes and that the regular school budget will support the main cost of program administration and operation?

Getting Started

Getting started on an arts in general education program may (and probably should) take as long as a year or two, depending on the size and complexity of the school system, the configuration of the proposed network, and the obstacles encountered.

Ideally, the initial impulse to start the program comes from the school district, but it can also come from a variety of other sources: a Junior League, a private foundation, a college or university, a state or community arts council, an arts institution, a group of concerned citizens. Regardless of its point of origin, community groups should understand from the beginning that the school system is legally responsible for the education of children and must have the final say in decisions which affect this process. While the school system must be committed and involved from the outset, the superintendent may choose to delegate some of the initial research and planning responsibilities to committees or task forces.

Some of the strategies that have been employed (sequentially or simultaneously) by League sites during the planning phase have been to:

- *Form a planning committee* consisting of key professionals and practitioners from the school system, the arts community, colleges, and civic organizations. The planning group's task is to design a comprehensive program. It should:

 1. Examine the rationale, definition, and concept of the arts in general education and their application to local conditions.
 2. Study the local and national scene for promising programs and practices.
 3. Conduct a needs assessment and identify existing and potential resources—human, material, financial—in and out of the school system. Determine where the gaps are and suggest how to close them.
 4. Prepare a proposed comprehensive plan with specific program objectives, activities, time line, and outcomes and include an evaluation design.
 5. Suggest the size, composition, and operational structure of a network and determine whether it should consist of

one tier of "demonstration" schools or include additional tiers of "cooperating" or "satellite" schools.

6. Suggest the size and composition of a coordinating "hub" and define its administrative organization, role, and responsibilities.

7. Check out all details of the proposed plan with potential participants.

8. Report results to key decision makers in the school system and the community.

9. Formalize acceptance of the plan and announce intentions publicly.

• *Form an advisory committee (optional).* The original planning committee can usually be converted into a consultative body. Responsibilities, roles, and functions should be redefined.

• *Identify the personnel for program management.* Coordination may be provided by a single person working in consultation with others or by a multidisciplinary team. In most situations a team seems to work better than a single person since many diverse talents and abilities (not to mention time and energy) are required to coordinate a comprehensive, interdisciplinary program. The coordinators should be capable administrators and have decision-making authority and power. They should have practical knowledge of the arts, curriculum, and instruction and understand how the schools and the system operate.

• *Inform all schools in the system of the opportunity to volunteer for the program* (by letter of invitation, public event, the media). Include the rationale, the need for, and a description of the proposed program, the commitments of the district [and partner(s)], and guidelines and criteria for participation. Outline the time and task commitments required from the school and the benefits that can be anticipated. Request brief proposals for participation (declarations of commitment and intent).

• *Form a task force (or ask the planning/advisory committee) to screen proposals, visit the schools,* talk with administrators, staff, and parents, and make recommendations for participation.

• *Identify schools and announce participants.* Describe the configuration of the network and the rationale for its formation. The

original network should be small enough to manage and large enough to notice.

- *Form the network.* Hold planning meetings to discuss and clarify the concept and the program. Chart an immediate and long-range course based on needs and concerns as identified by coordinators, supervisors, and network principals and their staffs. Teachers can also be included, providing size is not a problem, the tasks are appropriate, and their role is an active not passive one.

- *Review existing and secure additional resources.* Allocate or re-allocate them based on the needs as identified. Decisions should be made in consultation with the schools.

- *Visit the schools to help them get started.* The coordinator(s) should meet periodically with each principal and staff to discuss the school development process and how the arts can facilitate it. They should also help schools form a planning committee to identify needs and opportunities and strategies for implementation.

- *Meet with artists, arts and cultural resource organizations, and arts agencies* to define overall program purposes and needs. The coordinator(s) should examine existing programs and services, suggest new approaches to be planned jointly with the schools, and organize planning meetings.

Building the Program at the Grass-Roots Level: School Development through the Arts

In arts in general education program networks, each school forms a planning committee. Depending on the size and nature of the school, the planning committee, often led by the principal, can consist of the entire faculty or a representative core group (supervisors, generalists and specialists), all of whom volunteer for the task. Parents, artists, student leaders may also be represented.

The five basic questions for each school are:

1. How can our entire school develop and change through the arts?

2. How can the arts and the creative process be integrated into the daily classroom experience of every child in this building?

3. How can the school meet the five main objectives outlined in

the system's plan to which it has made a commitment—strengthen and expand study in the arts; promote interdisciplinary teaching and learning; use community resources more effectively; meet the special needs of special children; reduce personal and racial isolation?

4. How will the school meet its own objectives, such as increased attendance, higher morale, reduced vandalism, better attitudes toward learning, greater community and parental involvement, maintaining racial and ethnic balance, and better integration of staff and students?

5. How will the school relate to and communicate with other schools in the district, the network, the region, the country?

League members have employed the following strategies to answer these questions:

- Monthly meetings of demonstration school principals and program coordinator(s) to discuss issues, meet with consultants in the arts and education, and define, redefine, and evaluate plans and programs. These meetings may take place at a school, at the central office, or elsewhere in the community. They should be mandatory (part of the commitment each principal makes when volunteering to join the network).

- Site visits by network principals (and staff) to network schools (and in the case of the League, to other sites) to observe what is happening, talk with administration and staff, and explore a particular issue or problem in depth. These meetings are conducted by the host school principal [or site coordinator(s)] and follow his/her agenda. The program coordinator(s), central administrators, partners, and other resource personnel participate. When appropriate, local and national officials are also invited to these occasions.

- Half- or full-day schoolwide planning meetings in which the entire school staff assembles to define and solve issues and problems related to their arts in general education program.

- Network retreats or all-day planning and development conferences.

- School/community events, fund-raising affairs, showcases, festivals, performances, exhibits to which the media are invited.

- Staff and curriculum development activities, in and out of school (on school time, after school, for credit or not).
- Meetings with artists, arts and cultural organizations, and other resource personnel to jointly plan and develop programs, services, and events.
- Artist residencies: short and long term, by individuals and resource teams.
- Evaluation efforts (questionnaires, reports, observations, interviews, standardized tests, narrative histories, etc.).
- Documentation and dissemination activities (conferences, seminars, workshops, reports, portfolios, videotapes, film, exhibits, manuals, newsletter articles for school and local newspaper).

Mid-Course Corrections

As programs move "off the page" into operation, they develop a life of their own. Changes occur and, in domino fashion, these changes precipitate others, of which some are desirable and some are not. It is essential for participants and decision makers to be responsive to the flow of current events in order to make appropriate and timely adjustments.

- *Establishing and maintaining balance among program components.* Frequently, the first year or so of operation will focus on some of the children, one or two art forms, and one or two of the five main objectives. While obviously all aims cannot be realized simultaneously and immediately, and one does have to start somewhere, extreme care must be exercised so that programs do not become "unbalanced," one-dimensional, or for a limited number of students.
- *Reorganizing the hub.* The hub often changes as programs develop. A single coordinator may find that it is difficult if not impossible to manage all the complex aspects of a comprehensive program without additional help. If the hub is a team, its personnel may not adequately reflect the variety of talents and abilities required. Staff turnovers may result in leadership gaps. When these events occur, they should be recognized as a good opportunity to reorganize the hub and to redefine administrative roles and responsibilities.
- *Reorganizing the network.* Many networks in the League have

remained relatively stable. Inevitably, however, principals retire, move to other schools, or fail to follow through on their original commitments. Some may feel after a year or so that the program makes too heavy a demand on their time. Others may be disappointed in what they perceive as a lack of special recognition, extra resources, or financial support.

In addition to network membership, other questions of an organizational or practical nature may arise: Was the original group of schools too small, just right, too large? Were the number of tiers and the number of schools in each manageable, and did they make programmatic sense? Has the concept of the arts in general education been internalized and given adequate time and support to flourish? If the strength of the network appears to be in jeopardy, it is often both wise and necessary to consider reorganization. Guidelines and criteria for membership can be updated and the original schools given a fresh chance to declare their continuing commitment or to opt out. New schools may be added, and/or schools may move from one tier to another. New and functionally related networks may be formed. In all cases, participation should continue to be voluntary and membership policy should now be formulated in cooperation with the network principals.

Extending the Concept, Enlarging the Network—or Both

At some point, generally after about two years of school-based operation (we are now at about year three or four), the question of expansion is inevitably raised. Key decision makers are encouraged by signs of the program's effectiveness and staying power and continue or increase their support. Other schools in the system are beginning to want "a piece of the action." The word has gotten out, with some evidence to support it, that the arts in general education concept offers schools another way to reach their goals. And there now exists a substantial amount of experience that can be shared with others verbally and in writing.

The question of how the concept can be extended to other schools can be looked at in several ways: feeding new schools into "open slots" in the original network, enlarging the original network, setting up new and related networks, or a combination of all three. Fundamentally, it means "going public."

Following are some of the ways that have been used by League sites:

1. A school system, seeing the value and effectiveness of the idea in a few demonstration schools, declares the arts in general education a priority for all its elementary and secondary schools and encourages principals and teachers to join the program in a series of sub- or mini-networks, all coordinated by the central office. Increased staff and administrative time is allocated from central, and the original demonstration network provides consulting and training services for the new schools. Curriculum guides, administrator manuals and resource books based on actual experience are provided as references.

2. Programs begun in a few primary or elementary schools gradually and systematically expand to all elementary, then middle, and ultimately senior high schools. Technical and consulting assistance to facilitate this process is provided by curriculum supervisors from central, arts resource teams, and a buddy system between original and new schools. Program, staff, and curriculum development materials support this process. Schools are sometimes grouped in subnetworks according to grade level, program emphasis, or location.

3. In systems which have districts or areas, "mini-" arts in general education networks are set up within geographical boundaries using the original demonstration schools as reference points and their staffs as resource personnel. The same planning process is undergone, and schools still volunteer and compete for participation. Main administrative support is provided by the district office with supplementary assistance coming from the central office, the hub, and the community.

4. School systems under a desegregation mandate create magnet and special emphasis schools, some of which focus on the arts and the arts in general education. These schools form their own networks, are often staffed by former "demonstration school" principals, and are served by the coordinator or arts resource team from the central board.

5. The central office sets up other networks using the arts in general education model process and interrelates the arts with the particular area of study, e.g. career, environmental, ethnic heritage, and special education. Arts in general education principals, staff, and management, plus central board or district supervisors, assist in this process through leadership, staff, and

curriculum development workshops and conferences. Manuals and other publications are used as references. These "new" networks have functional relationships with the arts in general education network.

6. Title IV-C and other state funds grants are used to adapt and test out the arts in education concept in other schools and sites in those states that have declared the arts in general education a priority and eligible for funding. In this case the state education department, in concert with the state arts agency and local school districts, takes responsibility for coordination and servicing of a statewide network, and with the original demonstration sites provides information and consulting expertise.

7. Regional networks involving a number of neighboring states are established with local, state, and federal funds using the original AGE district as hub and headquarters for dissemination activities, a source of technical and consulting assistance, and staff and curriculum development materials.

8. State and local arts councils that have been intimately involved as partners or sponsors of arts in general education programs spread the word to their constituency and to other schools and school systems.

9. National programs, such as the National Endowment for the Arts' Artists in Education Program, the National Endowment for the Humanities, the Special Projects Act of the Emergency School Aid Act, the Department of Education/Kennedy Center's Alliance for Arts Education Program, and the National Institute of Education, help to initiate or support the concept of the arts in education through competitive grants and categorical aid.*

The above are organized and formal ways to extend the arts in general education concept. Following are some which are informal, indirect, or often accidental:

• Superintendents, chief administrators, and principals move to new positions or places and take their philosophy and experience with them.

* As of this writing, Arts, Education and Americans, Inc. and the Rockefeller Brothers Fund are also engaged in activities which recognize and, in some cases, reward outstanding arts in education programs.

• Principals and staff from nonnetwork schools meet principals and staff from demonstration schools sharing certain arts resources. Ideas and information are exchanged and certain arts in general education practices are put into effect in nonnetwork schools as a result of cross-fertilization.

• National volunteer organizations (such as the Junior League) and civic groups (such as the Urban Coalition) which have been involved with arts in general education programs share their experience with other schools and organizations through conferences, newsletters, and other publications.

• Heads of schools in programs such as a principal-as-leader program or other school improvement programs which subscribe to an educational change theory similar to that upon which arts in general education programs are based, pick up on the idea through formal and informal meetings, conferences, and other means of communication.

My good friend and colleague, Carol Fineberg, who was instrumental in the development of the New York City program and active in the League, is fond of saying, "If you don't know where you're going, all roads lead there." The above guidelines are posited on the opposite but complementary notion that all roads lead to Rome providing, of course, that Rome is your chosen destination.

SCHOOL DEVELOPMENT THROUGH THE ARTS

The Concept of School Development

School development is a grass-roots concept. It assumes that the individual school is a definable unit—a social microcosm—capable of organizing and governing itself and delivering quality learning experiences to all of its students.

The word "development" is significant because it does not have the connotations of other phrases like "school reform" which are often associated with dissatisfied outsiders who intervene in (or interfere with) the schools theoretically "for their own good." The article of faith is that school people, given the proper motivation and support, can chart their own destiny.

The concept of school development is based on a fundamental, though paradoxical, assertion: change is constant. Like it or not, there are no absolutes, no eternal verities, no final solutions to anything in a complex, technological world that keeps making or stumbling on discoveries that shake the very foundations of past and often sacred assumptions. Thus, school development must be a responsive, flexible process.

The idea of school development casts the school in a new role. It is no longer simply an institutionalized baby-sitter, a surrogate family, or a convenient mechanism for vocational training and enculturation. It is a new kind of social service center or, as John Goodlad has put it, a "pedagogical service station" that must provide and integrate a broad array of educational, social, and other supportive services to every member of its community.

School development is a tall and somewhat abstract order in our impatient, cost-conscious, and accountability-addicted society. It is not a sexy idea nor a packaged deal that promises quick, flashy (and thus flash-in-the-pan) results. However, it is a concept that, given time, can be translated into reality and made to work in certain settings and under certain conditions.

The Characteristics of School Development

The Process

Schools that are engaged in the development process are orderly, lively, and responsive. They usually have the following characteristics:

- A well-defined philosophy and a commitment to quality education for all the children in the school.

45

- A comprehensive school-based plan that has been collaboratively designed on the basis of school needs and resources. This plan specifies aims for the school, defines roles and functions of all participants, and integrates teaching and learning opportunities across program areas and subject disciplines.

- Regular schoolwide and small group meetings to discuss, decide upon, and assess instructional and other programs that have been cooperatively planned and carried out within the established comprehensive framework.

- A schedule that is flexible enough to accommodate unexpected program opportunities, team teaching, and resource and information-sharing.

- An on-going staff and curriculum development effort, in and out of school, which responds to needs identified by the participants.

- Linkages and partnerships with the community that tap or create new learning opportunities in and out of school.

- An evaluation system that keeps track of individual and collective progress, feeds information back immediately to those who need it for diagnostic or prescriptive purposes, and helps improve everyone's understanding of child development, the learning process, and schoolwide change.

- An effective communication system that keeps the school community informed and up-to-date about current events and future opportunities and generates the respect and support of parents and the community.

The People

People in schools engaged in the process of governing and improving themselves have the following general roles, functions, and characteristics:

- *The principal* is an educational leader, a politician, a social engineer, and a management expert with a point of view. He or she keeps order, sets high standards, takes risks and chances and knows when to lead, when to delegate or share power, and when to follow. He or she is a presence and is visible in the classrooms and the corridors as well as in the office. He or she has respect for staff, parents, and students, which is returned in kind. His or her

administrative and support staff share responsibility, act as a team, and provide instructional and moral support to teachers, students, community volunteers, and outside consultants.

- *Teachers* play a significant role in shaping the school's philosophy, planning school programs, and making financial and programmatic decisions that affect the school as a whole. They work singly and in teams, during and after school on projects and activities that are often collectively planned and implemented. They exhibit a sense of pride and ownership in their workplace and have high expectations for their students. They are aware of each other's strengths and limitations and function accordingly. They recognize that learning can take place outside of as well as within the school and use community resources regularly.

- *Students* are actively engaged in the life of the school and help to formulate ideas for programs, events, and the general curriculum. The extent of involvement varies according to age and maturity, but their pride in the school is manifest. They are courteous and friendly; they also laugh a lot.

- *Parents, school aides, and volunteers* are active on school committees, in the classrooms, and as liaisons between the school and larger community. They are advocates for the school and help secure resources for programs and events which they help to plan and carry out.

- *Professionals of all ages and from all walks of life* act as resource personnel to the administration, staff, and students. They participate in program planning and perform supplementary instructional and other supportive services.

- *Maintenance personnel* are involved in plans and decisions that affect their job responsibilities and, when appropriate, help teach skills peculiar to their craft or amateur interests.

The Conditions
The conditions necessary for school development are:

- Articulate, coordinated, and sustained commitment and support from top and middle management in the community and the local school system and, if possible, state and federal agencies—in words and deeds

- Availability of resources—human, material, and financial; additional funds for planning, research, and development

- Time and opportunity for planning, meeting, training, and socializing

- The existence of a network of like-minded schools coordinated by a facilitating hub

- Partnerships or collaborative arrangements with public and private agencies and institutions at the local, state, and federal level

- Specialized on-site technical and consulting assistance which is provided in response to the school's perceived needs

- Community awareness, support, and advocacy for public education

School development programs can survive in spite (and sometimes, because) of dramatic shifts in social or political policy, sudden and substantial reductions in education budgets, and shifting or diminishing populations. However, it is doubtful whether school systems threatened with near-bankruptcy or other chaos-producing situations would be able to initiate, let alone sustain, the process. A certain degree of stability is essential though it will vary in nature and degree from place to place.

"Why the Arts, Not Artichokes?":
A Rationale for the Arts in Education

During one of the early orientation and training seminars for central administrators and supervisors in the New York City AGE program, Edythe asked, "Why the arts, not artichokes?" as a focus for school development. There was a startled pause, some nervous fidgeting, and finally lusty laughter. The question seemed so frivolous, so out of keeping with the intense solemnity of the occasion.

The question has rung in my ears for a long time. During the meeting there were some valiant but feeble attempts to answer it and as I look back, I realize we failed to come to grips because we didn't yet understand its implications. With the benefit of hindsight and a poet's license, I will interpret and rephrase the question and suggest some answers.

Edythe meant: What do the arts offer schools in their search for self-improvement that artichokes do not? What is the unique contribution the arts can make to the growth and development of the total school? How do the arts, the arts process, and artist in all of us affect:

- The school's sense of itself, its philosophical purpose, and programmatic direction
- The attitudes and behavior of everyone in the building, from the principal to the custodian
- Teachers teaching and learning from others
- Students learning and teaching others
- The school's relationship with its immediate and larger community
- The climate and environment of the school

Kathy and I were struck by Edythe's question and about a year later, as we were preparing material for the January-February arts in education issue of *Principal Magazine,* hammered out a rationale for the arts in education. The rationale, although still largely a theoretical and not programmatic answer, has been widely used to substantiate a variety of claims for the importance of the arts to schooling. It is reprinted here in its entirety.*

A RATIONALE FOR THE ARTS IN EDUCATION

Many educators, as well as persons directly concerned with the arts, share the conviction that the arts are a means for expressing and interpreting human behavior and experience. It follows, therefore, that the education of children is incomplete if the arts are not part of the daily teaching and learning process. Arts in education programs are designed to make all of the arts integral to the general, or basic, education of every child in entire school systems. Work with these programs demonstrates that changes take place in schools so that they become humane environments in which the arts are valued as tools for learning as well as for their own intrinsic sake. Experience further indicates that the arts are useful to educators in meeting

* Reprinted by permission, The JDR 3rd Fund ©1980.

some of their main goals—that is, providing a great variety of educational opportunities, distinguished by quality, for all children.

The following are specific ways that the arts can contribute to the general, or basic, education of every child:

1. The arts provide a medium for personal expression, a deep need experienced by children and adults alike. Children's involvement in the arts can be a strong motivating force for improved communication through speaking and writing as well as through drawing or singing.

2. The arts focus attention and energy on personal observation and self-awareness. They can make children and adults more aware of their environment and help them develop a stronger sense of themselves and a greater confidence in their own abilities. Through increased self-knowledge, children are more likely to be able to command and integrate their mental, physical, and emotional faculties and cope with the world around them.

3. The arts are a universal human phenomenon and means of communication. Involvement in them, both as participant and observer, can promote a deeper understanding and acceptance of the similarities and differences among races, religions, and cultural traditions.

4. The arts involve the elements of sound, movement, color, mass, energy, space, line, shape, and language. These elements, singly or in combination, are common to the concepts underlying many subjects in the curriculum. For example, exploring solutions to problems in mathematics and science through the arts can increase the understanding of the process and the value of both.

5. The arts embody and chronicle the cultural, aesthetic, and social development of the world's people. Through the arts, children can become more aware of their own cultural heritage in a broad historical context. Arts institutions, cultural organizations, and artists have a vital role to

play in the education of children, both in schools and in the community.

6. The arts are a tangible expression of human creativity, and as such reflect man's perceptions of his world. Through the arts children and adults can become more aware of their own creative and human potential.

7. The various fields of the arts offer a wide range of career choices to young people. Arts in education programs provide opportunities for students to explore the possibility of becoming a professional actor, dancer, musician, painter, photographer, architect, filmmaker, or teacher. There are also many lesser known opportunities in arts-related technical areas such as lighting engineer, costumer in a theater, or a specialist in designing and installing exhibitions in museums. Other opportunities lie in administrative and educational work in arts organizations such as museums, performing arts groups, and arts councils.

8. The arts can contribute substantially to special education. Educational programs emphasizing the arts and the creative process are being developed for students with learning disabilities, such as the mentally retarded and physically handicapped. These programs are conceived as alternative approaches to learning for youngsters who may have problems in adjusting to more traditional classroom situations. The infusion of the arts into the general education of all children also encourages the identification of talented youngsters whose special abilities may otherwise go unnoticed or unrecognized.

9. The arts, as a means for personal and creative involvement by children and teachers, are a source of pleasure and mental stimulation. Learning as a pleasant, rewarding activity is a new experience for many young people and can be very important in encouraging positive attitudes toward schooling.

10. The arts are useful tools for everyday living. An understanding of the arts provides people with a broader range

of choices about the environment in which they live, the life-style they develop, and the way they spend their leisure time.

Kathryn Bloom
Jane Remer
November 1975

The Characteristics of School Development through the Arts

In October 1975, I put together a working paper entitled "A Definition of a Comprehensive Arts in General Education Program." Rereading the piece, I made an interesting discovery. I kept equating the program, the process, and the distinguishing features of AGE with a comprehensive school-development effort; they were interchangeable. In other words, my assumption then was (and it has since proved to be correct) that when a school goes about planning and executing an approach which makes *all* the arts integral to the general, or basic, education of *every* student, it must, *by definition,* change. That is, when a school sets out to design and carry out activities to meet the five main objectives, new instructional programs, new methodologies, and new patterns of behavior inevitably result. In addition, if a good portion of the school community is engaged in the process and the arts are used as content and instruments for change, the social climate and physical environment must also alter. Presumably these changes are for the better when quality as well as quantity is a criterion.

Put conversely, school development through the arts is a concept (all the arts for all the children), which is based on a change theory (the principal as leader, supported by networking and collaboration) that outlines the process by which individual schools design and carry out a truly comprehensive AGE program. When these programs have certain characteristics, they result in some identifiable and tangible outcomes which improve the quality of education generally.

What follows is an updated version of the 1975 paper, which I still consider in the "working" stage:

School Development through the Arts

School development through the arts is a concept and a long-range process which is supported and accelerated by networking and collaboration. When schools have as their goal "all the arts for all the children," and plan and install comprehensive programs to achieve that purpose, fundamental and positive changes take place.

Characteristically, these programs view the arts as tools for learning in all subjects, media for expression and self-discovery, and important areas of study in their own right. They are also recognized as an impetus to staff, curriculum, and leadership development.

A comprehensive arts in general education program is not simply a cultural enrichment program, an arts exposure project, or a curriculum development effort. It is not just a series of performances, visits to a museum, or encounters with artists for inspirational purposes. It is not a music appreciation or studio art course once or twice a week for thirty minutes, or a few electives which are not required (and therefore not considered "basic") for graduation. It is not a set of curriculum materials or a special program which affects only a few children or one or two grades in a school.

When a program is truly comprehensive it affects and alters the entire school. It includes the visual, performing, literary, environmental, industrial, home, and folk arts. It develops conceptual, thematic, and functional relationships among the arts and between the arts and all other subjects. It identifies and regularly uses all the appropriate arts and cultural resources in the school community in ways which increase an understanding of the arts and establish connections among the arts process, the creative process, and the learning process. In addition, it uses the arts to meet the needs of special populations (including the gifted, talented, handicapped, and bilingual) and to help reduce personal and racial isolation.

All participants, including chief administrators, principals, supervisors, teachers, artists, parents, and other resource personnel, assist in program planning, execution, and assessment. By engaging in the process, they develop a sense of pride and ownership in the program and the school and become effective advocates for the arts and public education.

Some Outcomes to Anticipate

The clue to the answer to Edythe's question—why the arts for school development?—actually lies in the rationale which makes a case for the arts and in the AGE program goal: *All* the arts for *all* the children in *entire* schools. The proposition we were testing was that the daily and pervasive presence of the arts in a school and their integration into the teaching and learning process of all students could help to effect total school reorganization and revitalization so that all children would benefit.

Following are some of the outcomes that I have observed over the years in schools which are working toward change through the arts:

- Learning in the "basics" is not jeopardized; it tends to be strengthened.

- Attitudes toward school and attendance improve among both students and teachers. Vandalism, alienation, and violence wane and a sense of personal pride in and ownership of the school develops.

- Morale climbs; people feel better about themselves and less isolated. They start to work together and learn how to come up with creative solutions to traditionally difficult problems.

- New and improved programs, services, and activities emerge. New instructional approaches and materials are developed and widely shared.

- Better and more varied programs in the arts and in arts-enlivened curricular areas tend to attract certain segments of the population who are wary of public education.

- Principals, teachers, parents, and resource personnel behave in different ways individually and as a group. Roles and responsibilities change; new talents, abilities, and interests are identified and tapped.

- Students take a more active part in the life of the school. Their motivation for learning is increased and as they find new avenues for self-expression and success, they relate more freely to their peers and "mentors."

- The climate of the school becomes livelier, more vital, and the environment changes from institutional drab to colorful.

- Interest, support, and involvement of the local and general community in its schools is increased and vice versa. Parents become articulate advocates and active participants in school life. The school building serves as a community center for arts and cultural events.

- Many of the broader socio-economic as well as academic aims of education are met, in whole or in part. The need for public education and the value of the arts to the process are visibly reinforced.

- Existing financial, material, and human resources are used in broader, more effective ways; new resources are attracted as programs demonstrate their value.

This list deliberately omits the claim that basic achievement skills rise solely because of the presence of the arts, or that standardized test scores and minimum competency ratings improve because of an AGE program. Variables influencing these assessments have yet to be isolated, let alone controlled. It stands to reason, however, that if a school becomes a better workplace and the people in it are proud and comfortable, productivity and general learning should improve. While both common sense and experience seem to support this statement, it would be a good agenda item for the field of educational research and evaluation.

School Development through the Arts and the Broader Aims of Education

When school development through the arts is examined in a broader context, the fit between the arts and education, and more specifically how arts in general education programs can help schools develop and attain generally accepted educational purposes, becomes apparent.

John Goodlad describes four categories of goals for schooling in the U.S.*:

1. Academic (functional literacy)

2. Vocational (readiness for productive work and economic responsibility)

* *What Schools Are For,* John Goodlad, Phi Delta Kappa Educational Foundation, 1979, pp. 44; 46–52.

3. Social and civic (socialization for participation in a complex society)
4. Personal (self-fulfillment)

He breaks these broad categories into twelve goals based on an analysis and synthesis of statements by state and local boards of education:

1. Mastery of basic skills
2. Career and vocational education
3. Intellectual development
4. Enculturation
5. Interpersonal relations
6. Autonomy
7. Citizenship
8. Creativity and aesthetic perception
9. Self-concept
10. Emotional and physical well-being
11. Moral and ethical character
12. Self-realization

Superficially, goal 8 seems to be the only place where the arts have a direct and indisputable role to play in the broader aims of education. On closer inspection and in light of the preceding pages, it becomes apparent that the arts can help schools reach *each* of the twelve commonly agreed-on educational purposes—directly or indirectly.

The eyes of the school superintendents and school board members invariably light up when I maintain that in our approach to AGE, the arts are not just for the gifted and talented nor for the cultivation of the so-called ''finer'' side of human nature. What really rivets their attention is the notion that the arts can help them as chief administrators and policy-makers realize their overall instructional and social objectives, galvanize community support for the schools, and add a touch of class, glamor, and excitement to the process.

Recent clinical research in the synergistic relationship of the left and right brain hemsiphere functions indicates the importance of the affective domain to balanced, holistic learning and intellectual as well as

emotional development. As evidence mounts, it is clear that the case for the arts in the schools and the role they can play in human development will be considerably strengthened.

"This Is Not a Santa Claus Project, But . . .": AGE and What's in It for You

On one of my first consulting trips to Hartford, Edythe (by then the new superintendent) asked me to help Paul Dilworth launch their AGE program, explain its purpose, and describe its benefits. During the course of a meeting, her assistant superintendent for elementary instruction, Charles Senteio, said to a curious but still skeptical group of principals and staff, "This is not a Santa Claus Project, but what it offers you and your schools is . . . ," and he went on to mention a long list of items.

The phrase was a good one, and I have used it ever since because it answers in part the first question asked by most newcomers to AGE: "What's in it for me?" They mean, of course, how much money and resources are available, and what will their share be?

It was always difficult for people to accept the fact that a partnership with a Rockefeller did not automatically mean bushel barrels full of money. It also took a lot of talking to convince people that we did not have a prepackaged program designed to improve basic skills whose results would be measured in easily quantifiable and impressive numbers. Perhaps the most difficult task was to explain that AGE was a fairly well-defined although flexible concept which had to be put into daily practice in each school's own inimitable fashion. School people are not accustomed to being given ownership of an idea, let alone the encouragement and support to work it out in their own settings.

Most folks were finally convinced of the sincerity if not the total authenticity of our explanations. They simply refused to believe there would be *no* money and no additional resources. They usually proved to be right, but it was the kind of money that the program gradually attracted, in bits and pieces, not up-front, massive, incentive funds. The "hidden" resources were primarily those that already existed—largely untapped—in their own schools and community.

The inevitable question posed during discussions of this kind was if there wasn't any money, etc., then what on earth was there to make the commitment of time and effort to the network and AGE worthwhile? When we first began, our answers were quality education for all chil-

dren, personal and professional growth and fulfillment, strength and comfort in unity, consulting assistance, and a whole string of intangibles. It was probably not our rhetoric but our fervent and crusading spirit which persuaded a number of courageous principals and teachers all over the nation to join with us. I am sure they suspected all the while that we had both "the program" and the money up our sleeves.

In addition to the general benefits I have mentioned previously under the heading of outcomes, there are now some more specific answers to the question of "What's in it for me?" The answers come directly from the mouths and experience of school board members, administrators, principals, teachers, parents and students. I offer some of them here by way of testimony:

> "AGE is a *you* program. The principal is respected as a leader and encouraged to make innovations." (Principal)

> "What better way to improve the quality of school life than through the arts in education? It is an instructional approach and a social framework that has given me a new way of looking at my whole school." (Principal)

> "An arts in general education program helps a school change and broadens the decision-making base. It is also good politics because it's one of the few things everyone can support. It commands community attention and city and nationwide support." (Chief administrator)

> "AGE has helped me attract and keep middle-class parents of all races and backgrounds. It is a force for integrating my school population as well as the instructional program." (Principal)

> ". . . an integrative approach that builds and maintains morale, improves the school tone and ambiance, and helps staff relate better to each other and the kids." (Teacher)

> "I think this effort of ours has restructured the classroom teachers in our system right back into the mainstream of

the arts and education in general. I think that may be the ultimate significance of what we're doing because unless the teacher is excited and involved, education is going to be pretty boring." (Superintendent)

". . . an interdisciplinary approach that helps put me in touch with the rest of the staff. Together we make conscious use of the arts for their own sake, but we have discovered that they tend to increase students' mastery of skills and concepts in other subject areas." (Arts specialist)

"It is the first approach I have encountered that is truly comprehensive in its goal—all the arts, all the children, all the time. As such, it is an instructional framework based on psychological contracts that allows for a very broad and therefore very creative interpretation. It breaks the conventional educational mold." (Chief administrator)

"AGE is one of the programs we point to with pride. We've always believed the arts are basic and we know they're not controversial. The program here helps us defend the arts when it comes time to strip the budget. We always have to fight, but the fight's getting easier in spite of what you read in the papers." (School board member)

"Arts in general education has been a key force in our desegregation plan, but it's much more than that. Good God, who in the world wants their kid to go through a so-called minimum competency program? So they can have a seventh grade reading level and brag about it? Our building principals understand this and they are the key to the success of this program." (Superintendent)

"Many collaborations between artists and schools are superficial. This is generally not the case in AGE. Artists usually function differently in AGE schools. They fulfill the needs of that situation according to how the staff defines it, and residencies often result in new courses

that are teacher-designed and taught. In addition, working in AGE schools has opened new professional vistas and new creative possibilities for artists; it is also a very fulfilling personal experience." (Arts agency administrator)

"I chose to move to this neighborhood and buy a house because I could send my kids here. I believe in the AGE philosophy, and I volunteer my time to teach clay-modeling whenever I can." (Parent and PTA president)

"Working as an artist in the schools, especially the class-rooms, is difficult. But what a difference it makes when you're in an AGE school! In some respects, you work twice as hard, but the rewards are also twice as great. This is true, of course, in any school with a deep commit-ment to the arts and to all the kids." (Artist)

"I never knew I could dance. It makes me feel good. I like to know I can reach for the stars." (Student)

AGE may or may not look like a Santa Claus project at the outset, but the programs *have* attracted federal, state, and private resources and it would be naive and misleading to leave the impression that partici-pants commit to it solely for intrinsic rewards. Theodore Berger of the New York Foundation for the Arts (an administrative arm of the State Council), for example, estimates that over a ten-year period a substan-tial portion of about $1,000,000 in direct and indirect services has been allocated to New York City, much of it earmarked for AGE. Little Rock, Seattle, and Winston-Salem have also been the beneficiaries of federal, state, and local arts and special project education dollars. AGE does take money; it is probably the multiplicity of sources it can tap and the purposes for which supplementary funds are used that help distinguish it from the financing of some other school improvement efforts.

A DAY IN THE LIFE OF AN AGE DEMONSTRATION SCHOOL: P.S. 152 BROOKLYN

At Least Two Gingko Trees and a Kiosk Grow in Brooklyn

It is 9 A.M. on a cool, drizzly day in May. I arrive at Public School 152 in Brooklyn, a 72-year-old brick building surrounded by a wrought-iron fence and not just one but lots of budding trees, including two lovely gingkos and some ravishing azaleas. The community is mostly residential and the Brooklyn College campus is close by. The first thing that catches my eye is an outdoor kiosk (actually a series of wooden display cases on the front lawn) presided over by a large painted figurehead whose abstract features remind me of an Indian totem pole. I have come to visit my old friend and colleague, Dr. Herbert Shapiro, principal of one of the original AGE demonstration schools. I want to learn more about the story behind the construction of the kiosk, and I also want to get a close look at an AGE school that has spent over five years planning and developing a comprehensive program.

I am eager to experience the climate, environment, social atmosphere, and human dynamics of this large elementary school which houses over 1,300 predominantly black and Hispanic students in three separate buildings, two of which are on the Brooklyn College campus. I have arranged to spend the day with Herb to observe classes and activities and to talk with his staff, students, and those volunteers and professionals who happen to be around on this particular occasion. My intention is to try to capture the often elusive kinds of things that happen in an AGE school.

I have selected Herb's school from among the more than 150 AGE schools in the League for several reasons. First, P.S. 152 is one of those with the longest experience in the program nationally and it has had more than its fair share of urban traumas. My feeling is that if AGE can survive and thrive in a New York City school, it can survive anywhere. And while P.S. 152 may be unlike any other school in some respects, its profile may be instructive to believers and skeptics alike.

Second, a seventy-five cent, one-hour subway ride to Brooklyn has obvious advantages over a long, expensive plane trip to other League sites. Considerations of time, money, and geography always play a part in decisions of this sort.

Third, oddly enough, in all these years I have never visited the school for one good reason or another. Having heard so many rave reviews about it for so long, I felt it was high time to see for myself what all the noise was about. Besides, my impressions would be fresh and uncolored by past experience.

Fourth, Herb is a thoughtful, analytic, and deceptively low-keyed person who through the years has raised intelligent and often disturbing questions about AGE. He has expressed some reservations about taking a bunch of theories on sheer faith but has nonetheless kept working toward "the goal" deliberately and systematically.

Fifth, he is not a flashy man, but I have learned that Herb's still waters are not all that quiet and do indeed run deep. The father of three, he is a sculptor, a photographer, and a recent convert to disco dancing. On one of the League's first site visits (to Seattle), he got caught up in the spirit of the occasion and insisted that I teach him how to "disco." I remember him literally dancing in the aisles on the plane ride back to New York, much to the amused astonishment of most of our fellow passengers. I wondered at the time what kind of a school a man such as this might run, and I was determined to find out sooner or later.

For these and other reasons, P.S. 152 seemed an appropriate school to study for the book. Some day, perhaps, I will have the time and opportunity to do similar profiles of many more of the equally qualified AGE schools across the country.

Profile of the School

Size and Staff

- Kindergarten through sixth grade (the latter housed in two "quonset huts" on the Brooklyn College campus)
- 1,330 students, approximately 80 percent black and Hispanic and the balance white or other
- Average class size: 30 students
- 50 classroom teachers (length of service in this school from 1 to 15 years)
- 11 cluster (specialist) teachers: 2 instrumental and 2 vocal music; visual arts; physical education; creative dramatics; science; language arts; English as a second language (E.S.L.); library
- 5 reading specialists
- 1 part-time guidance counselor
- 6 paraprofessionals
- 7 school aides
- 3 secretaries

- 3 custodians
- 1 security guard
- 2 assistant principals
- 1 principal

Total: 80 instructional, supervisory, and professional staff plus:

- Artists (visiting and in-residence): architecture, dance, photography, interdisciplinary team
- Parent and community volunteers
- Student teachers and observers (Brooklyn College)

Physical Facilities

Three buildings: original, 72 years old; new wing, 26 years old; annex (two quonsets) 5 years old. Three floors and basement in main building; one in quonsets. Large playground, front yard, large auditorium with stage, gymnasium, library.

School Patterns, Styles, and Designations

"Open," "informal," "experiential" education. Heterogeneous grouping in mostly self-contained classrooms. Intellectually gifted children's (IGC) classes, mandated by the district. Team teaching (three pairs of two teachers, plus artists and parent volunteers, "paras" and aides in various groupings). Title I (educationally disadvantaged compensatory funds); Beacon Light School (early 1970s); AGE School (1975 to the present).

District 22, Home of P.S. 152

One of thirty-two in the city, located in the borough of Brooklyn. Six AGE schools (two of which are "demonstrations") in a district of twenty-nine schools (twenty-five elementary, four intermediate and junior high).

When Is a Day a Typical Day?

There are dangers in observing a school on a so-called typical day, especially when there has been advance notice of the visit. School people like the rest of us can't resist putting their best feet forward and their nicest and cleanest clothes on "for company," and I have sometimes encountered marathon and dismayingly artificial show-and-tell

productions. There is no way of completely eliminating this tendency, but it can be controlled. Herb and I discussed this several weeks before my arrival and agreed that apart from some special meetings, I would observe the school on a normally scheduled day which was picked at random, mostly for my convenience.

As it turned out, it was indeed a typical day—for New York City. One of the assistant principals had just been reassigned part-time to another school in the district, leaving Herb and the remaining assistant principal alone in charge during the busy and often hectic early morning hours. Ushering in over 1,330 students and overseeing a huge staff in a three-building and overcrowded school complex is a demanding job even for three able administrators; for two it was almost overwhelming.

The average citizen has literally no idea how many problems elementary-school-age children can create or have created for them: lost notes from home; lame but imaginative excuses for absences or tardiness; inexplicably lost brothers or sisters; sudden and suspicious stomach aches; unexpected quarrels or blows between schoolmates, each of whom naturally blames the other for starting the dispute—the list could go on endlessly. Most of these problems are quickly and skillfully resolved by experienced administrators who are wise to the ways of childhood, but some of them are complicated, often requiring a number of phone calls in the hope of reaching a nonworking parent or responsible adult. All this takes a great deal of time, not to mention patience and fortitude. I doubt whether the number of incidents was significantly greater than on any other "average" day; it just seemed that way to me because Herb was doing two jobs simultaneously.

In addition, quite a few classroom teachers were out ill and several had been "released" to participate in program-planning sessions or staff-development activities. This meant that most of the "cluster" (specialist) teachers were covering regular classes (thus canceling their usual schedules) and that a number of substitute teachers were coping as well as could be expected with unfamiliar children, inherited lesson plans, and an altered school schedule. Add to this the usual but controlled frenzy of end-of-the-year testing, preparation for special community events, graduation exercises, and the search for time to plan programs for the coming school year, and you begin to get the picture. Things were popping.

I am accustomed to these phenomena and so is Herb, who kept his balance and sense of humor throughout, never losing his "cool" even in the most difficult or potentially explosive situations. They are the all-too-familiar signatures of a large, crowded urban school, although they

don't usually occur all at once, in a torrent. Despite everything, however, it was school business as usual. Classes ran smoothly, meetings took place, breakfasts and lunches were served and even eaten, corridors were quiet and clean, tempers were controlled, and a lot of people were smiling, laughing, and intensely engaged in their work and play. On reflection, it certainly was a typical day, at least in the Big Apple where, if anything can go awry, it will.

The Visit Schedule

Once the early morning crush and crises were under control, Herb took me on a guided tour that was occasionally interrupted by a call for help from the office but which resumed quickly and lasted the entire day. Our schedule consisted of:

Morning
Visits to all classrooms in the main building and conversations with teachers, paras, aides, parent volunteers, student teachers, and students.

Noon
Two consecutive meetings with supervisors, teachers on the AGE planning committee, the PTA President, and an artist (architect) in residence.

Afternoon
Visits to classrooms in one of the sixth grade quonsets on the Brooklyn College campus and conversations with staff.

Throughout the Day
A running dialogue between Herb and me about the school, the district, the New York City AGE program, and the League of Cities.

School Climate and Environment

There is an old bromide in education that asserts: You can tell the quality of a school the moment you set foot inside the front door. In the case of P.S. 152, I didn't even have to get that far; the kiosk, the azaleas, and the gingko trees were the first clues. Once inside the door, I was greeted by an obviously permanent (not for show) display which proclaimed P.S. 152 as an AGE demonstration school, listed the arts resources in the building, and projected a color slide-tape of school-based arts-related

activities. The resources listed were an interdisciplinary arts team, an architect and a photographer "in residence." I later learned that these were only the tip of the iceberg.

As I proceeded to the office, I noticed photos, pictures, paintings, and drawings everywhere. Once inside, I saw student-made copies of Impressionist and modern masters such as Van Gogh, Chagall, Klee, Cezanne, Modigliani, Dufy, Leger, and Seurat. I have never been too keen on children copying "great" art, but Herb later expained that the purpose was to develop perceptual skills, promote an understanding of the artist's creative process, and encourage teamwork, since several of the pictures were group efforts. The quality was unusually good and Herb was justifiably proud.

As I went from building to building, I was struck by the quantity, quality, variety, and originality of visual art displays and by the amount of poetry and creative writing hung on bulletin boards in the corridors. While not all classrooms were equally vivid or colorful and, of course, a few were virtually barren, I will list a sampling of what I saw, all of which was children's work:

- Masks, puppets, ceramics, sculpture
- Weaving, batik, macramé, woodworking
- Mosaic tile sculptures, cloth collages
- Islamic color designs based on algebraic equations
- Tin-can cameras, homemade darkrooms, and photography displays
- Homemade wooden "lofts," paper sculptures
- Cardboard murals, musical instruments

I did not see any of the performing arts in action—music, creative dramatics, or dance—because the classes had either been cancelled or were not scheduled at a time when I could catch them. I also missed seeing Sharon Sutton, the architect in residence, in action, although she was there that day and joined one of the noontime staff meetings.

The buildings were clean, the classrooms were airy, and the auditorium and the gymnasium were well-equipped. With few exceptions, there was a climate of warmth, respect, and purposefulness. Large as it is, the school is obviously a community, a work space, and a very safe and pleasant place to be.

Evidence of AGE in the Teaching and Learning Process

The reader will recall that there are five main objectives which provide the instructional framework for a comprehensive AGE program: In brief:

1. Interdisciplinary teaching and learning in which the arts are related to each other and to all subject areas

2. Quality instructional programs in all the arts for every student

3. Effective and extensive use of school and community arts and cultural resources

4. Special arts opportunities for special populations with particular needs

5. Use of the arts to help break down racial, cultural, and personal isolation

While my purpose was to observe in order to portray, it is hard not to make an evaluative statement. It became quite clear from my observations, conversations, and interviews that P.S. 152 has developed a well-rounded and exciting AGE program. While it does not (yet) include all the arts, all the students, or all the teachers all the time (an impossible dream, but a worthy goal), a conscious effort has been made to build a fluid, comprehensive approach. I will use the first and most difficult "objective" to implement—interdisciplinary teaching and learning—to illustrate my point.

In the majority of classrooms I visited, I saw the arts and the arts process being used as content (end in itself) and as a concept (means to another end) for learning skills, knowledge, and information in various curriculum areas. Some teachers were working at it consciously, others by instinct or natural inclination.

Example: In a fifth grade classroom the teacher, Eleanor Comins, was presiding unobtrusively over what amounted to a five-ring circus. Eleanor is a ceramist, considers herself an art for art's sake person, and while she encourages personal expression, is high on self-discipline and group harmony. When I walked in, three students were busy in the darkroom developing their tin-can films; another group was weaving place mats under the supervision of a parent volunteer; others were doing batik or clay sculpture. Still others were working on their own, reading, writing, painting, and so on. A few were composing imaginary

music on a cardboard electric guitar, complete with "cord" and "amplifier."

Out of curiosity, I asked three of the kids to explain the process of tin-can (pinhole) photography and show me how to develop the film. A professional couldn't have been more articulate. Mathematics, creative thinking, problem-solving skills, manual dexterity, aesthetic judgments, and teamwork were some of the more impressive components of this impromptu demonstration which was carried off with pride and enthusiasm.

After Eleanor showed me around, we sat down to chat. I asked her how she felt about the arts as aids to learning in other areas. She looked horrified.

"I'm really a purist, you know. I don't believe the arts should be *used* for anything except their own sake."

I persisted: "But you're a general classroom teacher and the arts are all over this place. Why?"

"Well," she said warily, thinking I might be trying to trap her, "what I'm trying to do is encourage my students to make their own discoveries and decisions, solve their own problems, feel more self-control and self-reliance, be creative, get along better with each other. What better way than through the arts?" She stopped short and we both burst out laughing.

"Case rests," I said.

Eleanor did *not* say she was using the arts to improve reading scores, nor did she say the only way to learn math was by using arts concepts or processes. What she did say, in effect, was that the arts are a powerful force in the three main domains of learning—cognitive, affective, and social—and they seemed a natural ally in her daily teaching responsibilities.

Many teachers in Herb's school share the same feeling. Several are very articulate about using the arts not only for their own value but for other ends. For example: Ida Arbital teaches sixth grade algebra through the construction of fascinating geometric designs and beautiful tile mosaics. Fran Kaplan, a vivacious third grade teacher with a professional background in music, drama, and dance, says she has been using the arts for years as a natural teaching tool "for just about everything." When I asked jokingly what on earth she was doing as a general classroom teacher, her shotgun retort was "sublimating"!

It was a funny but telling response. There are a lot of unofficial and often unidentified artists in our classrooms masquerading as "just"

classroom teachers. In P.S. 152, these hidden talents are sought out, prized, encouraged, and given recognition and reward.

Lack of time and space prevent me from going into detail on the manifestations of all five objectives. The reader will simply have to take my word for the fact that there are quality programs or activities in many art forms, special opportunities for students with particular needs, and use of the arts (current and planned for) to improve social and human relations and to increase parent involvement in the life of the school. A special word, however, must be said about the use of community resources.

Artists and resource personnel have been visitors to or in residence at P.S. 152 for several years. Photographers, poets, visual artists, dancers, and interdisciplinary teams are some examples. Some are practicing professionals, others are parents or volunteers. For example, the PTA President and member of the AGE committee, Diane Reiser, teaches clay modeling; a father took a day off from work to conduct a science/environment tour of the school backyard; another mother teaches weaving. Brooklyn College's School of Education supplies student teachers and observers and is now planning a school-based cooperative program; it also makes its library and other facilities available. The Brooklyn Academy of Music, the Brooklyn Museum, and several arts organizations in Manhattan provide services on a regular and extensive basis.

Community resources

One of the outstanding examples of the use of community resources is the Architecture-in-Residence Program of the National Endowment for the Arts Artist in Education Program. Sharon Sutton, a professional architect who is also a born creative teacher, has been working with P.S. 152 (and other AGE schools) for two years, and plans are under way for her to continue. Funds for her services are supplied on a matching basis from three sources: the school (PTA and other money), the district, and the New York Foundation for the Arts, which administers the program for New York State.

Last year, Sharon worked with several classes on architectural concepts, design, and construction skills. The experiences culminated in a ceremony honoring the permanent installation of the kiosk in the school's front yard, a project that ultimately involved the entire school, the community, and the district. This year's activities will culminate in the installation of a Street Museum that will display artifacts and historical information about the immediate neighborhood.

The conception, design, and construction of the kiosk has been

documented by a slide show with accompanying narrative. The process by which it was invented and shaped, and the incredible amount and diversity of skills developed and information learned, have been preserved on charts and folding cardboard placards. On the day I was there, the kiosk's eight display cases contained student exhibits with themes such as "painting space," "drama and space," "world of creatures," "space and geometry" (with geodesic domes), leaf and paper collages, and weaving.

Herb and many of his teachers feel that the kiosk project may well have done more to consolidate the school and its attempts to attract community support than any other single effort. I think another important result was the development of an entire "core" curriculum inspired by and related to architectural and design concepts. The school intends to transcribe the information contained on the charts and the placards for wide distribution throughout the district and to other AGE and arts in education schools. The program has already been singled out for distinction and is described in some detail in an *Architecture Bulletin* available from the New York City Board of Education.

The Principal as Leader: "We are such stuff as dreams are made on"

O God that Madest this beautiful earth, when will it be ready to receive thy saints? How long, O Lord, how long?
—George Bernard Shaw, *Saint Joan*

. . . God is on the side of the big battalions.
—George Bernard Shaw, *Saint Joan*

I believe in Michaelangelo
—George Bernard Shaw, *The Doctor's Dilemma*

Amor vincit omnia [or] Love conquers all
—Chaucer; Virgil

Genius is patience
—Popular proverb

The answer, my friends, is blowin' in the wind
—Bob Dylan

To dream the impossible dream
> —*Man of La Mancha*

In the epilogue to the Shaw play, Saint Joan, the former heretic, laments that the world is still not ready for the saints to come marchin' in. Her former comrade in arms, Dunois, is a pragmatist who states that God is on the side of power, raw and massed, and that battles are not won by sheer faith alone. Dr. Dubedat in *The Doctor's Dilemma* is something of a mountebank who nonetheless protests on his deathbed that his belief in great artists, science, and the Life Force will ultimately redeem him. Chaucer and Virgil seemed to think that love will prevail over adversity. Someone knew that patience was more than a virture. Bob Dylan lamented man's infinite capacity for destruction but saw hope for change. Don Quixote tilted at windmills to win his beloved Dulcinea and was oblivious to the world's scornful laughter.

What has all this got to do with the principal as leader? In my experience, everything. Rather than cite numerous references to the research literature on the subject of the principal as sparkplug and spearhead, I will give you my own list of characteristics. An effective principal is a Saint Joan, a Dunois, a Dubedat, a Chaucer, a Virgil, a survivor, a philosopher, and a Don Quixote all wrapped up in one person. He or she is:

- An unofficial saint with a vision (not by calling but by necessity) whose job is often lonely and controversial
- A pragmatist
- A bit of a dissembler but a sincere humanist
- A caring individual whose love for children—all God's children— is often the only reasonable explanation for perseverance
- An optimistic risk taker who knows the hard questions and believes that an answer is indeed "blowin' (somewhere) in the wind" if he or she can just survive the current crisis to discover it
- A dreamer with a thick skin who does not let occasional setbacks or petty jealousies get in the way of larger purposes

In other words, a good principal is an able educational and administrative leader who knows how to organize the staff so it has ownership and a certain amount of control and influence over decisions affecting the total school program. He or she gives teachers the freedom and encour-

agement to do their jobs, has clear and reasonable expectations, and knows how to balance an orderly structure with "happy abandon" to stimulate creativity and camaraderie. If a principal is not a skillful nego- tiator who can help the school community arrive at consensus on issues of consequence, chances of the school's ability to be responsive to the needs of its children are slim.

I know many principals who fit this description and regardless of their personal style, they are all unorthodox. Herb is only one example of those men and women who are all to some degree mavericks with a vision. Herb is staunchly independent. He balks at arbitrary, autocratic behavior and believes unswervingly in what is known as informal, experiential education. He appreciates individual differences, dislikes tracking or labeling (stigmatizing) groups of students, and does his utmost to spread special opportunities around to as many people as possible. He is an iconoclast and, in short, he is a leader.

Spending the entire day with him, I was able to observe his attitude and behavior with staff, students, and parents. He was alternately stern, affectionate, funny, impatient with jargon or flabby thinking, suave, ambassadorial, and always sharp and clear-headed. He seemed never to be at a loss in any situation and was always quick to come up with a solution (or several) to a problem. A tall, attractive man in his early fifties, he is also remarkably agile and fleet-footed when the occasion warrants.

He knows (or so it seemed) everyone by name, and they all know him. He is modest by nature but lavish with his praise of others. In addition to all this, he is an educational thinker and philosopher and an adept administrator. He runs a tight ship and to mix metaphors, the trains run on time.

Interestingly enough, Herb admits that he likes being "the boss." He claims, however, that AGE has enabled him to let go of the reins a bit and to "broaden the decision-making base in the school." I was witness to the truth of his contention during the course of the luncheon staff meetings with the AGE committee. At issue were plans and preparations for a district AGE conference; disposition of the Street Museum; the Brooklyn college/P.S. 152 cooperative venture, Project Interaction and a grant to use the arts for better integration of staff, students, and parents; a schoolwide fund-raising event to secure money for the archi- tecture residency; and the school's posture vis-à-vis the district, the citywide AGE network, the state, and some federal agencies.

As each item was discussed, everyone felt free to voice an opinion, contribute ideas, and suggest solutions. Several issues were joined and

resolved; others, such as a planning meeting to chart a course for the next school year, were put off for future and larger group meetings. Responsibilities were voluntarily assumed and no one, including the United Federation of Teachers union representative, seemed to have any serious qualms about spending some personal time on jobs that they agreed needed to be done.

Make no mistake, Herb was still "the boss" and final decisions were his. Where a discussion wandered off course, he steered it back into focus. When time was running out, he moved rapidly through important items of information. At the conclusion of each session, however, there was a tangible sense of accomplishment and satisfaction. What's more, the dialogues, though serious, were peppered with jokes and humor.

In too many large schools, teachers feel isolated from each other and especially from the principal. In P.S. 152, there is a growing community spirit and a bonding of people engaged in a common effort. As Herb put it at a network principals' meeting, "AGE is a focus and a framework for making your dreams (of a better school) come true." The AGE Program at P.S. 152 is no pipe dream, and much of the credit goes to its principal.

The Problems

> We have done so much
> for so long
> with so little
> we are now qualified
> to do anything
> with nothing.
>> —From a printed card on Eleanor Comin's bulletin
>> board

> "The trick is to make a silk purse out of a sow's ear."
>> —New York City school administrator

P.S. 152 is a good example of how a city school can manage to survive budget cuts, teacher strikes, massive staff layoffs and turnover, and the difficulties of serving a school population that is in constant flux. The problems are severe but they are apparently not insurmountable.

- *Item:* The teacher turnover rate is such that only about one third have been on staff for more than five years. New or reassigned teachers come in every September. Orientation to the school and "indoctrination" into the AGE philosophy require time for meetings, workshops, and informal dialogue. Finding or making the time is a problem. One solution is teacher lunches with a prepared agenda; another is faculty conferences; a third is schoolwide "think tanks" where everyone concentrates on solving a few problems they have helped to identify.

- *Item:* P.S. 152, formerly a mostly white middle class school, has rather suddenly and very rapidly become 80 percent black and Hispanic. The new parent population is largely unfamiliar with the school's philosophy and approach. One solution will be to promote parent and student interaction and involvement using AGE as the vehicle.

- *Item:* While there are bits and pieces of money available from the district and a variety of sources for artists in residence and other special services, there is very little for materials. In an arts-oriented school, especially one so heavily engaged in the visual arts and architecture, this is a serious obstacle. Solutions include found and scrounged objects; teacher-bought, begged, or "borrowed" supplies; PTA funds and a very heavy dose of creative imagination. Cardboard boxes, for example, are flattened and used for murals and empty tin coffee cans become pin-hole cameras.

- *Item:* School-based staff and curriculum-development opportunities to build skills and learn methods for integrating the arts into daily instruction are key to an AGE program. The school day is crowded almost to "overload." Solutions are to build time for these activities into each program or artist residency; use sub days to release teachers; reschedule and make multiple use of staff for regular instructional services; and, when necessary, hold after-school workshops, for credit if possible.

- *Item:* Special planning and developmental funds for AGE are always hard to come by. Solutions are to join with other schools in writing state and federal proposals, hold PTA fund-raising events, piggyback on categorical aid programs whose purposes are complementary to AGE (e.g., gifted and talented, ethnic heritage, Title I, ESAA desegregation monies, special and bilingual education), and share resources with other AGE and non-AGE schools.

- *Item:* Teachers can resent the fact that scarce money goes to pay for artists when supplies, materials, and time for their own needs are in heavy demand. Partial solutions: patience, persuasion, and many opportunities for teachers to discover the artist's value as an educational consultant and a good liaison with the general community. (This is one of the perennial problems that will undoubtedly never be totally resolved unless there is a pot of gold at the end of the arts and education rainbow.)

The Impossible Dream?

At the end of the day, Herb and I sat alone in his office and talked. I asked him what pleased him most and least about his school in terms of AGE. His answers to the first half of the question were that people were feeling the stimulation of "outsiders"—other adults—and responding more positively. The threatening aspect of "replacement by" as distinguished from "working with" new blood was diminishing slowly but noticeably, and the quantity, if not always the quality, of visual arts in all the buildings was satisfying.

His response to the second half was startling but indicative of the man: "Comprehensiveness is hard to come by. I want to involve everyone and I want everything for everyone—all the arts for all the children. It's not an easy task. And I just can't seem to find enough time for total school planning, the kind of time—a day or so—that we AGE principals and others spend at our retreats. You know as well as I how important that is for progress, let alone for building the trust and confidence that lead to openness and cooperation."

Herb could have said that he lacked money to make so many of his dreams come true. Or he could have expressed reservations about some reluctant staff members. He could have said any number of things that pointed a finger elsewhere. But the essence of his displeasure was really a feeling of personal frustration that his vision had not yet fully materialized.

He might also have said something about the "basics," but as he stated vehemently at a meeting for new AGE principals: "This is not a program whose chief purpose is to use the arts to raise reading scores. This is a school development program that speaks to the whole child, the whole school, and all the people in it."

I left P.S. 152 tired and a bit giddy. It was a long but exhilarating day which served to strengthen my faith in the power of an idea when in the hands of capable, creative people whose dreams make the impossible seem easy.

THE LEAGUE
OF CITIES
FOR THE ARTS
IN EDUCATION:
SIX VARIATIONS
ON A THEME

How Members Were Identified: One By One

People have often asked me how the Fund got involved with the districts that ultimately formed the League. My first answer has always surprised them. We didn't pick them out of a hat, nor did we send out requests for proposals; they came to us—one by one. It was a gradual process of self-selection. The formation of the network was also a result of opportunity and, to a degree, necessity. We had no plans and no grand design for it at the outset, and we certainly didn't dream that the New York City plan would have such instant appeal, much less such easy applicability, to five other diverse districts. The Fund embarked on networking chiefly because it was the next logical developmental step in its own progammatic history.

The questioner is usually only partially satisified with that explanation. "But why those particular six cities?" is the next inevitable query. My response is that it was the result of people who were interested in the arts and education knowing people who were trying to do something about it. News of the New York City program had begun to spread rapidly through the nation's formal and informal arts-in-education communication networks and as a result of presentations and workshops at local and national conferences. Documentary materials were widely distributed in response to requests that poured into our offices and to those participating in the meetings we attended. But the six League districts surfaced mainly because someone who knew us personally or knew of and respected our work either cornered us at a meeting, picked up the telephone, or wrote a letter.

The New York City "connection" has already been described. In Minneapolis, Kathy and I knew the then superintendent, John Davis, and I knew two of his consultants. In Seattle and Little Rock, the first overtures were made by representatives of their Junior Leagues. (Kathy had worked as the Arts Consultant for the national association and maintained many contacts within the organization.) In Hartford, Edythe took the idea with her when she became their new superintendent. In Winston-Salem, the first approach was made by Kathy's friends on the local arts council and in the community.

The most difficult question has always been why the League was confined to six cities when there were other school systems asking to be included. Our answer was that as a private foundation, we could not take on the whole country; we had neither the time, the money, the staff, nor the mandate from our Board of Trustees. As a foundation, we

81

were attempting to fulfill our role as a stalking horse, and the League was a small field experiment. It was intended as a demonstration of an unusual educational approach which we hoped would provide food for thought, a model for study and adaptation, and a source of technical assistance.

The Fund's Criteria for a Partnership: Ten Characteristics of School Systems that Have Developed Effective AGE Programs

While many of the first contacts for information and help from the Fund came from people outside the school system, our practice was to accept requests for assistance only from the school superintendent or a chief administrative officer.

Following an official request, members of our staff would spend several days in a site describing the Fund's mission, the AGE concept, and the rationale for the arts in education. We would also distribute working papers and meet with key people in the school system and the community. The purpose of these visits was simple: both parties needed to get to know each other and find out, first hand, whether a partnership was viable and had a good chance of success. Although our approach and methods were informal, what we generally looked for was concrete evidence of certain characteristics or the potential to develop them before making any commitments. The traits we looked for are summarized in a paper I wrote in May 1974 entitled "Ten Characteristics of School Systems that Have Developed Effective Arts in General Education Programs": (The JDR 3rd Fund © 1980)

As has been stated frequently by one eminent educator, reading, writing, and arithmetic do not, in themselves, constitute an education; rather, they are the tools that one needs to become educated. We believe that the arts are also important tools for schooling and that quality education can result when the arts are incorporated in the teaching and learning process.

We have observed that when an entire school system embarks on an arts in general education program, certain kinds of changes take place in the schools and in the community. While not all the characteristics of change described here appear in every situation, they do identify main features

that are common to most of the school systems with which we have been associated:

1. *A Commitment to Quality Education for All Children*
 The school system has a commitment to improving the quality of education for all children and has established a mechanism for systematic change and innovation.

2. *A Commitment to Quality Education through the Arts*
 A significant number of chief school officials, administrators, teachers and parents subscribe to the belief that teaching and learning through the arts improves the quality of education for all children. They regard education as a creative living and learning process and feel that the arts provide a powerful motivation for this process. They have found that by incorporating the arts into all aspects of schooling, children develop positive attitudes toward learning, a stronger sense of themselves and a keener awareness of the world around them.

3. *The Creative Use of Existing Human, Financial, and Physical Resources*
 The school system allocates a significant amount of time, effort, and money to the planning and development of arts in education programs. Local public funds provide the main base of support for school programs; private funds are used primarily for research and development purposes. Existing facilities in the schools and the community are fully utilized.

4. *A Coherent, Collaborative Approach to Program Planning and Development*
 Programs are planned, developed, operated, and assessed by those who participate in them. Consequently, these programs relate to the actual strengths and needs of the district and individual schools and make use of the appropriate resources in the schools and community. Professional consultants in the arts and education are involved in the planning and development process.

5. *An Organic Program Design with Five Main Objectives*
 Though they will vary from district to district and school to school, effective arts in general education programs have at least five related objectives or points of emphasis in common:
 a. Interdisciplinary teaching and learning
 b. Strong programs in all the arts for all children

c. Effective and regular use of community cultural resources, including services provided by artists and arts institutions
d. Special programs for special populations
e. Use of the arts to reduce personal and racial isolation

6. *A Continuing Curriculum and Staff Development Effort*
Program planning and development occur simultaneously with curriculum and staff development workshops, seminars, and meetings. These activities encourage the development of new learning skills, teaching strategies, and materials that are appropriate to the content and structure of new programs. The instructional staff, artists, and community volunteers have access to new or existing arts resource materials and can test them out in actual classroom situations or other learning environments.

7. *An On-going Internal and External System of Documentation and Evaluation*
Evaluation of the school's efforts in program planning and development are continuous, largely internal, and address questions of effectiveness in terms of the goals and objectives the district and the schools have set for themselves. Judgments about quality and achievement are made by those best in the position to render and make use of them, and modifications are made as soon as they are needed. Educational research and evaluation consultants or outside agencies are used to help determine the effectiveness of the overall program.

8. *An Effective Communications Network*
A conscious and systematic effort is made to share information about the school's arts in education programs, and problems and prospects are discussed within each school, with other schools and cultural institutions, and with community advisory groups. As a result of this process, other schools wishing to move in similar directions are encouraged to do so more effectively.

9. *A Broadened and Humanistic Concept of Schooling*
In the course of incorporating all the arts into an entire school system, the concept of schooling broadens and teaching and learning become more humanistic. School buildings and classrooms are transformed into attractive living and working environments; the content of the curriculum is significantly

altered; teachers develop new capabilities and patterns of instruction; and a working partnership is formed between the schools and the community.

10. *An Increased Commitment to and Understanding of the Change Process in Education*
The process of educational change is often slow and difficult. It calls for imaginative leadership and cooperative working arrangements among many different sectors of the community. It also requires patience, fortitude, and broad public awareness and commitment. School systems that have developed effective arts in general education programs have not only improved the quality of teaching and learning in their schools but have developed a greater understanding of the change process. This process is generally most effective when the individual school is viewed as a social unit and the most powerful agent for progressive change in education.

The Unusual Nature of Partnerships

When each of the school districts and the Fund were satisfied that collaborative action would be mutually profitable, we entered into a formal partnership through the exchange of letters of agreement. These letters generally specified the nature, terms, and conditions of the relationship. The school district made:

1. A commitment by the superintendent and the school board to the goal of all the arts for all the children and to the development of a comprehensive program which would start in a few demonstration schools and gradually expand throughout the district.

2. A commitment to the idea of networking, collaboration, and school development through the arts.

3. A commitment of local district staff, time, and resources for program planning and operation and the assurance that additional funds would be sought from public, private, local, state, and federal sources to supplement tax-levy funds.

In return, the Fund agreed to:

1. Provide consulting and technical assistance from its staff in lieu of an outright cash grant.

2. Underwrite staff travel and expenses, certain "outside" consult-
 ant services by local and national authorities in the arts and
 education, and attendance by district representatives at special
 meetings and conferences.

3. Provide information about the Fund's experience with other
 arts in education projects, act as liaison between the district and
 other arts in education efforts, and function as a clearinghouse
 of information.

As noted in an earlier chapter, one of the unusual features of this
"contractual" agreement was the nature of the Fund's support, which
was basically technical and consultative and only indirectly financial.
Given our modest budget of $500,000 a year for a national program, it
might be said that we had no choice in the matter. Necessity was a factor,
but the governing reason was that New York City had taught us how to
use our limited staff and resources in more productive ways to affect a
much larger "target" population.

There were two exceptions to the no-grant policy. The first was
New York City where, because it was our own backyard and Mr.
Rockefeller felt very strongly about the city's public schools, we made
small $500 planning grants to each of the original twelve demonstration
schools and frequently helped out with the costs for special conferences,
retreats, and publications we felt would have national significance. The
second exception was in the form of two small grants ($6,000 and
$5,000) to each district (matched in cash, in-kind, and indirectly) to hire
and train potential supervisors in what we called the Arts in Education
Administrative Fellowship Training Program.

The Need and Opportunity for a National Network: Formation of the League

By 1976, in addition to my administrative duties and appearances at
national meetings and conferences, I was working on an almost daily
basis with the New York City Program and making two and sometimes
three visits a year to each of the other five districts. It became abundantly
clear that although our budget would hold out, my stamina might not.
We had already taken a page from our own networking book by forming
the Coalition of States for the Arts in Education, which indicated the

value and the feasibility of organizing a national consortium with a common goal.*

Thus, in April 1976, we invited teams of key administrators and program coordinators, about forty in all, from each of the six cities to a hotel on the outskirts of Chicago. We wanted to determine whether they, too, would see the advantages of forming a network whose potential benefits promised to outweigh any real or imagined threat to individual autonomy or integrity. Although we agreed to form the League at our first conference, it took several business meetings and site visits (and a lot of disco dancing, side-bar conversations, and late-night chats) to get to understand each other's speech patterns, establish a common vocabulary, and navigate the often choppy waters of contrasting styles and temperaments. But in a relatively short time, the group built the trust and confidence essential to cooperative action.

At the conclusion of that first historic and sometimes histrionic meeting, we managed to define and write our "mission statement" and sketch out a framework for the organization, structure, and operation of the new League of Cities for the Arts in Education. The Fund would continue to work with the individual districts, coordinate the network, and provide the main financial support for business meetings, conferences, and site visits. League members agreed to participate in all activities which would be jointly planned. They would work on task forces and special committees, organize site visits, and wherever possible, supplement the Fund's financial support from their own local resources. A steering committee, and ultimately a "core group" representing each district, was established to hammer out the details relating to policy, structure, and organization and to chart each step in the network's development.

While at first, ironically, it seemed that as League coordinator I would have more, not less, of a workload and an even heavier travel schedule, the formation of the network actually created a much more effective and efficient mechanism for mutual assistance, moral support, and leadership training that gradually reduced the number of site visits I felt obliged to make. In the sense and spirit of "two heads are always better than one," the large and small group meetings addressed and resolved, practically and immediately, through negotiation and consensus, more issues than any one person could ever hope to deal with in a lifetime.

* Arizona, California, Indiana, Massachusetts, Michigan, New York, Oklahoma, Pennsylvania, and Washington—all of which were also "self-selected."

Of two things I am now certain: first, there is no equal to the group process, no matter how slow or painful, for sparking ideas, generating creative and collective solutions to knotty problems, and building a sense of ownership, pride, and community. Second, the amount of money required to bring people together from different parts of the country is small compared with the benefits derived. Networking, even nationally, is a cost-effective mechanism for professional growth and development.

The League's Mission Statement and Declaration of Intent

The Mission Statement and Declaration of Intent were written and adopted unanimously by members of the League and read as follows:

Mission Statement
The goal of the League of Cities is to support and facilitate the efforts of its members as they seek to improve the effectiveness of education and the quality of life for all children and youth by incorporating all the arts in the teaching-learning process, and to make results available to others.

Declaration of Intent
The following cities—Hartford, Little Rock, Minneapolis, New York, Seattle, and Winston-Salem, in collaboration with the JDR 3rd Fund—have begun to plan and implement comprehensive school-development programs in order to reach the common goal of "all the arts for all the children." These cities have found it useful to meet together regularly under the auspices of the Fund to share information, resources, and effective strategies for planning and implementing comprehensive arts in general, or basic, education programs.

The League intends to enable participating school districts to:

- Raise the level of awareness of schools and communities about the value and effectiveness of the arts as a vehicle for school change, tools for living and learning, and areas of study in their own right.
- Demonstrate how the total climate, environment, and organiza-

tion of a school can be changed through the arts so that it becomes a place conducive to better teaching, learning, and living.

- Make better use of the arts, artists, and the arts process as one of several ways to achieve educational excellence in individual schools and throughout school systems.

- Avail themselves of existing human, material, and financial resources to support program planning, development, and operation.

- Take advantage of the leadership and other specialized knowledge and skills possessed by members of the League. As consultants and technical assistants to each other, League members can help design and assess strategies for program planning and for staff, curriculum, and school development.

The League of Cities further intends to develop and disseminate a position paper defining what we mean by the arts in education. We also intend to produce a notebook describing and illustrating the components and strategies for the school and school-district-development process through the arts based on our experience. Further, the League will make available to its members and others pertinent documents and materials related to the arts in general, or basic, education and school development through the arts.

League Activities: Business Meetings, Site Visits, and the Giraffe

Most of the League's business meetings were held in Chicago for financial as well as geographical reasons. The general format was a day and a half of four sessions, the first of which was devoted to information sharing about recent developments, new breakthroughs, and setbacks. The balance of the meeting dealt with one or more issues and a task to be accomplished. Usually teams of two to four representatives (administrators, coordinators, principals, and teachers) plus invited special guests (national authorities, interested observers, and arts agency administrators) attended.

The issues we discussed included: What does an AGE Program look like and how do you do it in your locale? What are the strategies for

school development through the arts? What are you doing about networking, curriculum and staff development, leadership training, and community awareness and support? How do you define roles and functions, especially for arts specialists and artists? What about resources, especially money, and how are you getting the good word out? How do you expand without going bankrupt and without violating the integrity of the idea?

Site visits had a somewhat different purpose and focus. The idea was for the host district to showcase its program with as little artificiality as possible and for League members to observe, participate in, and learn from the occasion. In addition to League members, local school folk, community leaders, and state and national dignitaries joined the proceedings.

The impact on the local scene was incredible. School people, parents, volunteers, and central staff—eager to plan each event carefully for maximum effect—made giant strides in their own understanding of the AGE concept and, in the process, got better acquainted with each other. The community became more aware of the existence of the program and of the positive role the arts could play in their schools. Administrators in the school system, especially the superintendent, the cabinet, and the coordinator, were given public credit for their accomplishments. Local teachers and principals were center stage and had several opportunities to share thoughts, concerns, and feelings with their counterparts from five different school districts. The students had a chance to perform, to express their pride in their art works, and to boast about their schools and their hometown to a group of sometimes bewildering "foreigners." A youngster from Little Rock once remarked to a New York City administrator, "Gee, you talk funny!" The administrator winked at me and agreed, saying, "Well, yes, you see, I've come from another country, according to my friend here. It's called New York City." The youngster, who'd caught the wink and, I think, the joke, laughed.

There is no doubt that the benefits to the "host" site tended to outweigh those to the visitors, although the preparation, organization, and the sheer physical labor involved were staggering. Additionally, the visits were relatively costly even though local expenses were more or less shared between the district and the Fund. But there is also no doubt that the experience helped to strengthen the bonds within the League by providing a first-hand glimpse of local conditions that no amount of talking or reading could ever begin to convey. Moreover, each visit was

unique and usually produced some unexpected answers to a few of the nagging questions that had been so stubbornly difficult to fathom "back home at the ranch." For me, each visit underscored the adaptability of the AGE concept. I continued to marvel at the idiosyncratic and creative approach each city had chosen to pursue while managing, at the same time, to remain faithful to the integrity of the basic idea.

Whether in Chicago or elsewhere, all of our gatherings were intense, riddled with humor, and exhausting. But somehow, we always managed to make time for dancing. Our favorite haunt was a place called the Giraffe discotheque in the Chicago O'Hare Hotel. The Giraffe became an important symbol for the League—a kind of password or inside joke because it served an important function. Given the isolated, in fact, desolate location of the place (near the airport), the Giraffe was the only nighttime entertainment available which allowed us to let off steam and at the same time keep together—an unwritten but somehow sacred "law."

Dancing became a hallowed League tradition. Wherever and whenever we met, it was always (if unofficially) built into our agenda; it became a habit and a necessity. Every time a meeting came to an impasse, there was always dancing. And if all was well, dancing made it better. I know for a fact that many fast and enduring friendships were formed and a number of problems resolved in that gaudy, noisy, wonderful place called the Giraffe.

AGE Proves to be Adaptable: Thumbnail Sketches of League Programs

When the partnerships with the Fund were first established, it was New York's experience and the New York City plan that proved instructive to the five other school systems. This is not to say that the New York City approach was taken on faith or followed blindly. Indeed, it was often difficult for some to imagine how anything that occurred in New York could apply to any other setting. However, where experience, processes, and working papers seemed to generalize, they were readily adapted to the local scene; where they did not pertain because of singular local conditions, they were set aside, sometimes for future reference.

A book of this kind cannot go into detail on each of the school district's programs. It can, however, give the reader a glimpse or two of a

few of the things that are happening in each place and cite a few examples. However, it may be helpful here to provide a thumbnail sketch of the origin and special aspects of each of the five programs not featured at length elsewhere.

Hartford

The Hartford AGE progam began in the fall of 1976, several months after it became a charter member of the League of Cities for the Arts in Education. General plans for the program had been made prior to the League's formation, but no official steps had yet been taken. At one of the League's early business meetings, the Hartford team presented a draft of its plan for general review and comment by members—a first for the League and a bold step by the team. An intensive session produced ideas and suggestions for revision and soon six demonstration and eight cooperating schools were identified, a network had been set in motion, and a considerable amount of financial and in-kind support from the school, arts, and business community had been generated. Hartford's AGE program has recently become a reference point for a regional arts in education network in which the state arts council, the state education department, community arts agencies, and concerned citizens are playing an important role.

Little Rock

The Little Rock Arts in Education Program began in January 1975 as a result of a joint effort by the Junior League, the Inglewood Foundation (a local philanthropy), and the school system. The venture was prompted by a district needs assessment which revealed deficiencies in arts education at the elementary level. After researching other national programs, including those in New York City and Seattle, a program coordinator was hired with modest grant funds from the Junior League and a $60,000 award from the Foundation for a three-year period. Five primary/elementary schools were identified, and an advisory committee was formed to provide direction and support for program participants. The program staff, now funded by the district and supplemented by state and federal monies, has grown from one person to five, and the arts in education schools now number twenty-seven of the district's thirty-eight elementary and secondary schools. The Little Rock program has attracted state and national funds and attention and serves as a beacon light to similar communities that must invent ways to tap limited local "natural" resources and engender widespread community support.

Minneapolis

The Minneapolis AGE program began in the spring of 1975 because the superintendent, his cabinet, and the school board felt it would be important to build upon and extend the experience gained from their Title III, ESEA-funded and nationally validated Urban Arts Program. This year-round program marshals the arts resources in the Twin Cities area and provides learning opportunities in schools, cultural centers, and studios for interested and/or talented junior and senior high school students who receive academic credit for their work. It also provides artists-in-residence, performances, staff development workshops, and curriculum materials. Urban Arts is now funded as a line item in the school-system budget and provides significant support for AGE/Urban Arts staff and school development activities. Additional support for AGE has been provided from the budgets of the Curriculum Office, the area superintendents, the State Arts Board (Council), and local businesses, corporations, and philanthropies. An arts cluster team coordinates the program for sixteen schools from the central office.

Seattle

The Seattle program, originally known as Arts for Learning, began in January 1974 with the major impetus coming from the city's arts institutions, the District's Curriculum Department, and the Junior League. The latter had conducted extensive research on national arts in education programs and approached the school district with a plan for a three-year pilot program. The program was launched in six demonstration schools with the Junior League providing a $40,000 planning and development grant. Following the pilot period, the original demonstration school network was reorganized and a number of new and larger arts-related networks were formed, representing thirty-one of the district's elementary and secondary schools. In addition to the steady support from the Junior League, the state education department, the state and local arts councils, and the city's arts community, rapid expansion was largely due to the district's financial commitment of federal and local money and its voluntary decision to desegregate the schools, using the arts as a focus for much of this effort. Seattle now forms the coordinating hub of a four-state regional pilot network, Arts Coalition Northwest, funded largely by the Department of Education and the Kennedy Center's Education Program.

Winston-Salem

The Winston-Salem Arts in the Basic Curriculum (ABC) program began

primarily because of the efforts of its local arts council, the first in the nation. Beginning with two elementary schools in 1975, ABC has systematically expanded into twenty-four elementary and most of the junior high schools (more than a third of the total system), using a "buddy" or pairing system which relies heavily on the support services from a multidisciplinary arts resource team, curriculum supervisors, and the education staff of the arts council. The program is classroom-teacher oriented and focuses on staff and curriculum development at the building level. It has received strong leadership and financial support from the superintendent, his cabinet, the school board, and the general community which is proud of its long pro-arts history. It is also the recent recipient of an Education Department grant. The program serves as a reference point for a statewide effort and has helped start similar initiatives in several states and territories.

NETWORKING
AND
COLLABORATION

"I Don't Mind Being Lonely if You Are Lonely, Too": The Goodlad Factor

During my first year on staff at the Fund, when I was not walking the New York City beat, I was deliberately and fairly systematically put through an orientation (more accurately, indoctrination) process by Kathy and her staff at the time: Gerry Hausman, Jack Morrison, and Gene Wenner. I traveled the country with them, visiting most of the "earlier project" sites located, for example, in University City, Missouri; Jefferson County, Colorado; Oklahoma City, Oklahoma; Mineola, Long Island; and Portland, Oregon. I also attended an awe-inspiring spate of national and professional conferences and had the opportunity to meet with, listen to, and learn from an impressive array of "elder statespeople" and current practitioners. The experience was invaluable.

It was on one of those early trips that I had the good fortune to meet John Goodlad, dean of the Graduate School of Education at the University of California, Los Angeles, and director of research for the Institute for the Development of Education Activities (|I|D|E|A|), the education arm of the Kettering Foundation. I had heard a great deal about John, and I was looking forward to meeting him in person. He had by then embarked on his ambitious Study of Schooling, and the Fund and the Rockefeller Foundation were supporting an arts component of this endeavor.

At our first meeting in his office at the University, I had an opportunity to mention the plans under way in New York City. John's eyes lit up. He told me that the school change theory, the principal-as-leader concept, and our approach to networking bore a striking resemblance to much of his own field and research work, especially the study concerning the League of Cooperating Schools in Southern California. It became readily apparent that although we were 3,000 miles apart geographically, John and I were next-door neighbors philosophically. We struck an informal bargain to keep in touch.

As time went by, the grantor-grantee relationship between the Fund and John developed into a partnership. We invited him to work with us as a program advisor and to participate in our dissemination conferences. He also spent considerable time as a consultant to administrators, supervisors, principals, and others in the New York City and the Seattle programs. He was invaluable to me as a friend and colleague and often had me join his |I|D|E|A| staff meetings where they wrestled with some of the thorny but fascinating problems presented by the

97

Study of Schooling. In addition to reaping the benefits of his counsel, I managed to learn more about the field of educational research and the many difficulties one encounters when attempting to gather and interpret reliable data about schools and schooling.

Among John's many talents is his ability to capture a complex but important idea in a single homily or chuckle-provoking quip. His oft-repeated statement, "I don't mind being lonely if you are lonely, too" neatly conveyed the notion that significant change means deviance from the accepted norm and therefore that strength and comfort are found in unity. Not totally original, perhaps, but certainly a pithy description of the value of networking.

John was convinced that AGE had more than a fair chance of success as an educational endeavor because it relied in so many ways on networking and collaboration. It is time to take a closer look at the phenomenon and some of its manifestations.

A Definition of Networking: Beyond the Rolodex

Recently someone said to me somewhat facetiously that a network was nothing more nor less than a good rolodex. The statement, like most wisecracks, has some truth to it, but it is too facile and misleading. A good rolodex is an important tool for matching people with the answers to those with the questions, but so is a computer if properly programmed. Networking is more than a mechanized computer dating game; it is an orchestrated, people-to-people process that requires a good deal of thought, patience, and nurturing to make it work. Let me give you a definition that I presented a few years ago at an "Arts and the Child" conference in Raleigh, North Carolina:

> *Networking:* The regular and voluntary coming together of people with common or overlapping concerns to discuss issues, share solutions to problems, and generate new ideas. Networking is an essential strategy in the planning and development of comprehensive arts in general education programs that have as their goal "all the arts for all the children." It provides a nonthreatening, cost-effective mechanism for communication, mutual support, professional growth, and concerted action. It also helps to promote the process of school wide change and improvement through the arts since it as-

sumes that those who are "doing it" are each others' best friends and resources.

Arts in general education networks break down professional isolation; they operate laterally, peer-to-peer, as distinct from vertically, top-down. They rely on what John Goodlad has termed the DDAE process: a continuing spiraling round of dialogue, decision making, action, and evaluation. Decisions are generally reached through negotiation and consensus, and individual needs are weighed against practical, political, and financial realities that affect the group as a whole.

To function effectively, all networks need a "hub," or organizing center. The hub usually consists of a team that provides leadership and support services to members. It coordinates activities; helps to maintain communication among program participants; identifies, secures, and "brokers" resources, and acts as a liaison between the schools and the community. It also provides on-site support and guidance for program planning and development.

Together, the network and the hub are a delivery system for technical and consulting assistance to each other and to a larger audience. They can provide authentic documentation and a tangible demonstration of programs-in-progress. They also offer a talent bank of experienced practitioners who can assist others in the planning and execution of their own arts in general education programs and help form related coalitions based on lessons learned from their own experience.

Arts in general education networks exist within and among individual schools and school systems, within and among state education departments, and on a regional and national basis. Networks within school districts often link administrators, school principals, teachers, students, artists, and arts organizations. They are generally large enough to notice and small enough to manage, depending on the size, structure, and resources of the system. Membership varies according to program needs and objectives, but it is always voluntary, not mandatory.

On the whole, since there is strength in numbers, these networks often prove to be the most effective advocates for progressive educational change using the arts as the content and vehicle for the process. In addition, since no one school, district, or program is exactly like another, networks offer the

general public a wide choice of alternative models to study, choose from, or adapt.

How Networking Can Build, Maintain, and Expand AGE Programs: Two Examples from the League

"The Perils of Pauline" and the "Pedagogical Party Line": New York City Revisited

People in the New York City AGE Program were no strangers to the art of surviving crises. They had encountered and managed to struggle through an impressive sequence of misfortunes, each of which seemed more severe than the last. "The walking wounded," as Kathy used to call them with affection and respect, bore their battle scars proudly. They felt that if they were able to prevail through several rounds of financial crises, teacher strikes and layoffs, changes in top administrative leadership, and divisional reorganizations, there was virtually nothing left that was formidable enough to do them in.

In the fall of 1979, however, AGE suffered yet another brutal series of what threatened to be death-dealing blows. Our main champions and stalwart supporters at Central left for university jobs or were shifted to other positions. A severe budget cut led to one more reorganization of the Division of Curriculum and Instruction and in the process, wiped out the line for the AGE coordinator. The formal partnership with the Fund, which served on several occasions as a bulwark against disaster, had dissolved when our program shut down. To this list add inflation, recession, and declining enrollments, and the dismal picture is complete.

In a sequence of events that reminded me of film clips from "The Perils of Pauline," the force for survival that emerged and ultimately proved victorious was the unified clamor of thirteen AGE demonstration school principals who stubbornly refused to give up without a fight. They proceeded to:

- Call emergency meetings, decide on a course of action, and form committees to carry out designated tasks

- Demand hearings, send telegrams, write letters, and generally "raise a ruckus" with the chancellor, his chief assistants, the acting head of curriculum and instruction, and other decision makers

- Contact congressmen and women, the media, and any other

influential voice they knew or could think of to bring attention to and pressure for their cause

The results were astonishing. They manifested themselves in the following ways and roughly in the following order:

- Money was "found" in a state-funded "Umbrella" program to underwrite a half-year salary for an AGE coordinator with the proviso that membership in the network would increase by approximately 75 percent. (Participation had fluctuated over the years and the current rank of active network demonstration schools had dwindled to thirteen with another group of ten "cooperating schools.")

- Sponsored by the Division of Curriculum and Instruction, a citywide "dissemination" conference was held at Central to announce the publication of the "AGE Administrators Manual" and "Architecture Bulletin" and to extend an official invitation to other schools to join the program. The conference hall was festooned with AGE displays. Chief administrators, a community superintendent, principals, teachers, and artists made presentations and then broke into small groups to lead discussions and answer questions. A fact sheet and proposal forms were distributed.

Raul Julia, noted actor and visiting artist in the program, struck a responsive chord in his keynote address when he said:

> You are the artist in your own life; be creative; take a chance, don't wait for money or resources to come to you; make your own commitment first. The commitment will generate the resources because AGE is a *good* program. It celebrates the artist in all of us and, frankly, I don't see the difference between being a good actor and an outstanding teacher.

- In addition to regular and emergency principals' meetings, a day-and-a-half "Retreat" (in the city, on school and personal time) was scheduled to make plans for expansion. We defined a new organizational structure for the network, spelled out roles and functions, and set the agenda for an upcoming meeting with new schools. By that time, it was clear that AGE had made some new and important friends at Central who were supporting the program by their deeds as well as words.

- A Convocation was held at Central for all new (about thirty-five) school principals who had completed the response form. The "Administrators Manual," "Architecture Bulletin," and other materials were distributed. The terms and conditions of participation were spelled out along with the benefits to the school community. At this meeting (again chaired by the principals), the chancellor's senior assistant for instruction, Ron Edmonds, coined a wonderful phrase in the course of his introductory remarks to the group. He described the AGE philosophy and approach to school development as highly complementary to the theory underlying his newly launched School Improvement Program and to the Local School Development Program initiated by the New York Urban Coalition. He noted that AGE was very much in step with the current "Pedagogical Party line" which maintains that schools *do* make a difference, if not *the* difference in the education of children. He added that he was impressed with the voluntary principal-directed aspect of the effort and promised his full support and cooperation.

- Meanwhile, we had gotten word of continuing financial assistance from the "Umbrella" program and were hoping to receive another Title IV-C state grant. Significantly, the proposal was written by Carol Fineberg, a former AGE coordinator, whose consultant services were paid for out of the demonstration school budgets. The principals had levied a tax on themselves.

- And finally, at an AGE party celebrating Charlotte Frank's appointment as director of the Division of Curriculum and Instruction, Chancellor Frank Macchiarola praised her leadership and assured us of his continued support.

These and many more events took place in the space of less than a school year, and while the story may not have direct application to any other school district, it does point up the dramatic powers of networking. It also demonstrates how a diverse group of principals can work in concert with no financial compensation to save a program as well as enlarge it. What's more, the very struggle for survival not only strengthened the program internally but gave it more visibility and credibility citywide than it had had in a long time.

One sobering comment. AGE had begun over seven years ago as a school change and development project, and "Design for Change" had been written three years before that. It took quite a while for the program

to be recognized and pronounced "in step." It is an important lesson in patience and perseverance, though small comfort to those principals, for example, who must struggle every day to run their schools and at the same time fight to keep a program they believe in alive.

A Study in Contrasts: The Seattle Story

In New York City, the AGE demonstration school principals not only saved the program but maintained their participation in it as a voluntary core group which would help expand the concept to new schools through a buddy system and other activities of a technical and consulting nature. The Seattle story is not quite so melodramatic but provides a good illustration of how AGE can expand rapidly when a school system chooses to desegregate voluntarily and takes another approach to networking.

The Seattle program began in 1974 as the Arts for Learning (AFL) Project in six of the district's seventy-eight elementary schools. The major source of funds for planning and development originally came from the Junior League, which made a three-year grant of $40,000 that was stretched to cover a four-year period. As the program developed and gained steady and tangible support from the district, local, state, and federal funds, both public and private, were quickly attracted.

In 1977, to avoid a possible court order, the district embarked on a comprehensive plan to desegregate the school system for which it received a substantial amount of federal assistance. On the basis of its experience with the AFL Project, the district felt that the arts were, among other things, a natural vehicle in the social as well as curriculum integration process and proceeded to establish a number of arts in general education or arts-related networks for all grade levels. In contrast to New York City, the original AFL network was deliberately disbanded and demonstration school principals were regrouped in a number of new consortia where they were expected to function as leaders and resource persons. At this writing, there are 31 elementary and secondary arts in education schools in the district's 106 schools. While an assortment of state and federal funds are now considerable, they are firmly undergirded by a strong commitment from the superintendent, his cabinet, and a general allocation of district staff, time, and money.

In the beginning there were lean years, a small staff, a series of almost devastating tax-levy failures, changes in the superintendency, system reorganization, and no full-fledged programs yet in evidence to provide tangible proof of AFL's value. Approximately six years later, the

arts are fairly pervasive in about a third of the district's schools. In addition, Seattle is a reference point for a statewide arts in education effort and has become the headquarters for Arts Coalition Northwest, a new regional program that affects three contiguous states, Alaska, Idaho, and Oregon.

The desegregation effort certainly provided the major impetus for rapid expansion, but there were additional factors which contributed to this "success" story: strong and articulate leadership at the top administrative levels, sustained support from the school board, parental and community satisfaction and pride, continued volunteer and professional assistance from the local arts community and the Junior League, and a good working relationship with the state's Department of Public Instruction and the federal Education Department. Not least important is the imaginative leadership provided by Arts Supervisor Ray Thompson and a core of so-called middle managers who stubbornly breathe life and excitement into the day-to-day operation of the program and make sure that the various networks maintain functional connections with each other and with various curriculum and support areas.

Thus networking and collaboration, although manifested in a very different way from New York City, have been the key to the growth of the program in Seattle. The moral of this story can perhaps be found in something Superintendent David Moberly once said to Ray Thompson and me:

> The arts are basic. They are a social, political, and educational priority for Seattle. As superintendent, I've got to be personally involved in the fight to maintain not just standards but flexibility in this urban school system. The arts are a good weapon to have in my arsenal. Besides, they're good for our public image.

The Benefits of Networking According To AGE Practitioners

The following quotes from practitioners testify to the advantages of networking.

> "It means linking hands across school, department, district, and other lines and joining in the search for solutions to the problems all of us share."

"Your sense of isolation breaks down; you get moral support and a lot of good ideas you, alone, would not have thought of."

"You enhance your reputation and attract attention and ultimately a lot of resources you never expected. The arts really are sexy."

"It's a Touchstone operation. You touch each other with new thoughts, sustenance, and creative energy and your battery gets recharged."

"It is nonthreatening; it gives you the courage to be brave, to speak up, to be enthusiastic without apologies."

"You can select solutions that suit you best from many different approaches."

"As an individual, you are vulnerable. When you're part of an AGE network, you are less so. And you are among equals."

"It's the best device for leadership training that I know. You get immediate cost-free, expert technical assistance from on-the-job practitioners that you'd probably have to pay a fortune for otherwise, assuming, of course, you could find the right consultant to do the job."

"You *do* get tangible assistance: Small sums of money, manuals, reports, and guidelines; access to national authorities, artists, and arts resources; and the help you need to write proposals to funding agencies you may never have heard of. You also learn how to pool and parlay what money you do have to maximize its use."

"The network is a recognizable field with a tangible commitment to a programmatic idea that works. Resources are attracted to that commitment because they know they'll get a big bang for their buck."

A Few Last Words on the Subject

By now, the benefits of networking and collaboration as strategies for change should be clear. But the process has its share of problems, and in the interest of balance and candor, I shall add a few last cautionary words on the subject.

- Networking is at the very heart of the AGE school development process, and like any heart, it must beat regularly to keep the body of the program alive and vital. Too often, this notion is either misunderstood or not fully translated into action. There is a tendency to think that, once a group of people, schools, or school districts is identified and officially declared a network, that is all that needs to be done. The network exists—on paper. Occasionally, administrators, principals, their staffs, or artists show up at meetings or events to engage in some activity that has been planned *for*, not *by* them, usually without their prior knowledge or consent. The results are generally boredom, impatience, and disenchantment—and in some cases, revolt.

- Networks operate laterally with group decisions reached through negotiation and consensus. The locus of power is in the group, not in any one individual. This power is elusive and has a tendency to shift and float, depending on the issue at hand and whose ox is being gored. Thus, decisions reached will almost always represent some sort of compromise in which everyone wins something, and no one loses everything. This mode of operation makes some people uncomfortable and others downright impatient, and it certainly flies in the face of standard bureaucratic practice.

- Networks cannot function without a hub, but the balancing act of power between the two is a delicate and difficult business. When networks are first formed, the hub often dominates the decision-making process. As time passes, network members get to know each other, become more secure in their understanding of program goals and objectives and more competent in carrying out their own individual responsibilities. As a result, they insist on a larger voice in policy and financial matters. Unless it is understood that the hub's main function is to facilitate program planning and development, and help members to help themselves,

discussions can turn into labor-management disputes and collective action will be blunted.

• The strength of the network is in its collective ownership and sharing of responsibilities. Although each member functions within a larger group, he or she can maintain his or her own identity and uniqueness while promoting the group's overall mission. But, unless the network serves primarily as a delivery system of assistance to its members and a reference point for others, it has no reason for being. If it is used or manipulated for other ends, its purpose will be subverted and its integrity destroyed.

• Networks are often accused of being elitist, closed clubs. There is probably no definitive way to dispel the jealousy or even hostility sometimes directed at members. There are, however, some partial solutions: expand the network and eliminate distinguishing categories (or tiers) so that no one is a second-class citizen, help form and participate in related networks, provide technical and consulting assistance to other groups and individuals, circulate or distribute information and resource materials to a wide audience, hold conferences and meetings to which all interested parties are invited. In other words, go public and be on record as supportive of all schools committed to the AGE philosophy whether officially AGE-designated or not.

• Networking, though cost-effective, does require money for coordination, special resources, consultants, events, released time, and, in the case of regional or national consortia, travel and lodging. In most cases, however, the value received by the large number of participants far outweighs the minimal per capita price tag. In 1978 for example, an average two-day League meeting in Chicago for twenty-five people cost the Fund about $6,000. School- and districtwide events, on the other hand, can usually be subsidized on a few hundred dollars and many for almost nothing.

PIECES OF
THE PUZZLE

A Lick and a Promise

When I was young, we had a housekeeper who, when she had more chores than she could manage in one day, used to say to me with a conspiratorial wink, "I'll give it a lick and a promise to do better the next time." I keep finding myself in much the same situation with this book. Each topic in this chapter, for example, ought to be probed in depth, but then we would end up with a book the size of the New York City telephone directory.

Except for the section on artists and the schools, I will be brief. I will identify the people and the institutions that fit into the three-dimensional jigsaw puzzle known as a comprehensive AGE program, make some general observations, and occasionally mention some sources to which the reader can turn for more information. A lick and a promise shall have to do for the time being.

Classroom Teachers: The Heart of the Matter

In all instructional efforts, teachers are the heart of the matter. In most innovative approaches, they are frequently by-passed or taken for granted. In AGE programs, teachers are involved in the design and execution of the plans for their school and are part of the decision-making process. When they are not, they either ignore or sabotage the program "behind the classroom door." The danger of an effort such as AGE is that the rhetoric touts the principal as the key to leadership. Unless teachers are comfortable with the arts, given time to discover how to use them in their own classrooms, and flanked by specialists, artists, and other "how-to-do-it" consultants, AGE will not materialize.

In Little Rock and Winston-Salem, for example, teacher leadership and ownership were built into the plan from the outset. There is now persuasive evidence of interdisciplinary teaching and learning in many of their classrooms. Most important, there is an effective peer-to-peer mechanism for staff and curriculum development because teachers who are "doing it" are sharing their ideas with others through institutes, workshops, newsletters, and informal conversations at teacher centers and professional gatherings.

111

Arts Specialists: Quality Control

Arts specialists can provide quality control and a built-in mechanism for staff and curriculum development when they are looked upon as resources and are consciously integrated into (not isolated from) the total school program. AGE has been attacked as a "conspiracy" against the specialists. Unfortunately, all too often, AGE programs *have* served to fill a vacuum *after* the specialists were let go *en masse*. Where AGE programs have survived, however, the result often is that more specialists are hired and more arts courses are offered.

Principals and others need to recognize that arts specialists, itinerant or otherwise, are a resource for better instructional programs, not simply baby-sitters for uncovered classes or a once-a-week cultural shot-in-the-arm. Arts specialists need to consider whether some of the reasons for their being let go when the crunch comes are the following: (1) the arts are still regarded as peripheral, not basic, (2) as specialists, they usually reach only a relatively small portion of the total student population, (3) they have a reputation, deserved or not, of preferring the gifted and talented, not "all" the children, and (4) they are generally isolated from their peers because there is no mechanism provided for them to connect with the rest of the school staff and/or they may often prefer to remain apart. Arts specialists will probably strengthen their own cause and that of all the arts for all the children if they insist on joining forces with the rest of the pedagogical staff and demonstrate how their services can benefit the entire school.

Artists: The Question from Kathryn Bloom

> Alice B. Toklas: "What is the answer?"
> Gertrude Stein: "What is the question?"
> Kathryn Bloom: "The question is not what education can do for the arts but what the arts and artists can do for education."

In the sixties and early seventies, I worked in and with a number of the city's arts and cultural organizations administering programs and services for students and teachers. At Young Audiences, for example, I coordinated a variety of in-school music performances and designed a pilot for dance which, though not immediately implemented, helped lay

the groundwork for a number of subsequent approaches taken by that organization. At Lincoln Center, I administered the New York City portion of the Student Program which consisted of visits to the Center and a series of in-school performances and lecture-demonstrations in vocal and instrumental music, theater, dance, opera, and film. I also designed and coordinated the so-called R.P. program (short for Resource Personnel) in which over one hundred professional young artists were trained to work individually and in teams with students and teachers. The program's purpose was to provide insight into the creative process and experiences in each of the art forms to enhance and illuminate the performances.

The R.P. program represented one of the Center's attempts to make the arts more accessible and more "relevant" to its clientele. Performances, program notes, and teachers' guides seemed to be making little lasting impression on the schools. Audiences were often restless if not downright rowdy; some appeared to resent their lot as captives of "just another assembly program." It was felt that if students and teachers had more direct and personal exposure to the art forms and extended classroom contact with artists, interest and attention would increase. They did, noticeably, but generally only for those students in the few classes to which the artists were assigned. Furthermore, even the most ardent principals and teachers tended to regard our program as cultural enrichment: a pleasant encounter for students, exposure to the "finer things," a brief diversion in the day's routine, but nothing to be taken too seriously. In other words, nice to have but not essential.

Over a five-year period we modified and refined our efforts. We had our successes and our setbacks—mostly the former, according to our school friends—but I was constantly bothered by the fact that regardless of what the Center did, the arts were not making significant headway up the ladder of educational priorities. We were somehow not getting to the heart of the matter, despite the numerous consultations and conferences we had with Board of Education and school representatives.

Working first with Edythe and then Kathy gave me a fresh perspective on the role of the arts and artists in the schools and the nature of the problems that confront "outside" organizations and schools when they attempt to work together. I thought I knew the schools and was sympathetic to their difficulty in accommodating themselves to schedules and production requirements that were often beyond their control or technical capabilities, but I was mystified by the superficiality of our impact. If

we were earnestly trying to do so much for and with them, why wasn't the response more meaningful? Certainly quality wasn't a problem, and in those days money wasn't either. Most of the performances and services were underwritten by private and public funds; the schools paid only a fraction of the total cost.

I eventually came to realize that I had been seeking the right answers to the wrong question. To paraphrase Kathy, it's not what the schools can do for the arts but what all the arts can do for whole schools and all the children in them. In other words, improving the status of and respect for the arts and artists in schools was important but not a primary goal. Instead, if the arts were used to improve the quality of education for all children, appreciation of them and respect for their value would be a probable outcome. It is a subtle but important difference, and it sets the stage for partnerships in which everybody stands to benefit.

In the last seven or eight years, I have arrived at certain conclusions based largely on my experience with the League:

- First, the interests and operating modes of schools and arts organizations rarely synchronize. When you are lucky, they overlap or converge—tenuously—and whatever partnership is established must be constantly worked on through negotiation and consensus, an often frustrating process given the barriers of time, terminology, and primary institutional purpose.

- Second, regardless of the relevance or merits of a program, the quality of services offered, or the thoroughness of artist preparation, schools and school systems will not alter their mode of operation, not to mention their attitudes, unless they are equal, and in some respects senior, partners in the venture from start to finish. Responsible for the health, welfare, and formal education of children, schools must not only be convinced of the inherent as well as potential value of a program, but they should have the final say about its general conduct (though not necessarily its artistic content).

- Third, artists could, for example, act as role models, resources, and catalysts for new school projects and events and enrich routine curriculum offerings, but unless a significant core of the school staff and the principal were committed to the arts *as* education and to artists as instructional resources to teachers, the arts would continue to remain on the fringes of school life. More important, unless programs and services were jointly planned and

carried out, no enduring changes of any consequence would occur.

- Fourth, visitors to schools, be they artists, consultants, or volunteers, are just that—visitors. Unless their credibility is established and their roles are mutually defined and widely understood, their potential contribution will be blunted against a wall of silence, indifference, suspicion, or even outright hostility. Many teachers, for example, resent the fact that an artist consultant is often paid more money for working fewer hours with less kids under nicer circumstances than are normally provided for the regular staff. In stringent financial times when teachers, particularly arts specialists, are being shuffled around or laid off, this is an especially bitter pill to swallow, even when a teacher recognizes the value of the artist's contribution to his or her class or own professional growth. Issues such as this must be met head on, openly and honestly.

- Fifth, the artists must be perceived as resources and supplements, not substitutes for licensed teachers. It is a thorny problem considering that in so many situations artists *are* being used to fill the pedagogical arts gap. Unfortunately, the arts are still among the first to go in budget cuts, and we can only hope that artists will "hold the fort" and help change the prevailing attitude about the value of the arts to general education.

- Sixth, artists have worked with schools for a long time, primarily as performers and guest instructors for a limited number of students. In traditional programs, the artist's presence is an end in itself. Generally, however, when the artist leaves, the excitement generated by new blood and fresh ideas disappears without a trace. There is no one left with the skills or training to carry on whatever momentum was established. In AGE programs, artists function as a means to a larger and more comprehensive end: the improvement of the whole school climate and environment and the upgrading of the quality and variety of its instructional offerings for all students. They also function as liaisons to the community and help generate local support for the arts and the schools.

- Seventh, many artists in the schools program founder on the rock of inadequate preparation of artists who are new to the schools. Some artists are born teachers; most are not and life in the schools bears little or no resemblance to life in the studio or garret. There is no longer any excuse for artsts to be sent into unfamiliar settings

and allowed to "sink or swim." Orientation and training are essential, and experienced artists and educators should be responsible for formal sessions that provide practical information, tips on the dos and don'ts, and a forum for the exchange of ideas that work. It is unthinkable that teachers would be allowed to work in schools without adequate preparation; the same holds true for artists.

• Eighth, unless there is a pot of gold at the end of the arts or the education rainbow, there will never be enough money from one single arts *or* education source to cover the full costs of artists' services to schools. The name of the game is, and will be for some time to come, collaborative funding.

This section has confined itself to the comments regarding the somewhat narrow and traditional concept of artists and the schools. There are a number of arts groups and organizations that deserve attention for the special work they are doing as school-based programs or service organizations. I urge the interested reader to study the programs of such organizations as Young Audiences, the Lincoln Center Institute, Growth through Art and Museum Experience (GAME), Teachers and Writers Collaborative, and Touchstone in New York City; The Performing Tree in Los Angeles; and Open Doors in Oklahoma City, and Urban Gateways in Chicago. I know there are countless others, but these are some I can attest to from first hand experience.

Arts Resource Teams: Flying Squads for Consulting and Technical Assistance

In League sites and many other arts in general education programs, Arts Resource Teams have proved to be an effective mechanism for staff, curriculum, and school development. They are also emerging as an important strategy for program expansion and extension of the AGE concept to a large number of schools within a district, state, or region. Seattle and Winston-Salem are outstanding examples of the creative use of these teams, and the reader can contact them for further information.

Arts Resource Teams are:

1. Multidisciplinary and can work singly or together. Planning and sharing time is built into their schedule.

2. Hired by the district (or by a public arts agency on behalf of the district) and paid for by local tax levy funds; federal, state, or community arts and/or education grants; foundation awards; private sources; or a combination of the above.

3. Employed for most of the academic year and often for the calendar year.

4. Generally composed of professionally licensed and experienced teachers (at the precollegiate or collegiate/graduate level) but may include professional artists with strong teaching background and experience.

Arts Resource Teams are trained to act as a "flying squad" of resource personnel. They can:

1. Train teachers, other instructional personnel, visiting artists, parents, and community volunteers

2. Work collaboratively with visiting artists and arts specialists (itinerant or school-based)

3. Function as liaisons between the district and the schools

4. Administer and coordinate certain aspects of the program and provide consulting and technical assistance to administrators, supervisors, and staff

5. Identify and secure resources (people, materials, space, time) for program development and support

6. Document and share program information with the schools and the community

7. Participate in assessment of program progress and make recommendations for improvement

Parents and Community Volunteers: An Invaluable Resource

Without parents, community volunteers, and Junior Leagues members, AGE programs would undeniably suffer. They are a free source of support, leadership, and advocacy of the idea. They can provide or teach special skills, organize and galvanize any number of fund-raising events, run conferences, write newsletters, operate resource centers, and develop resource kits. For a thorough and informative treatment of

this subject, I recommend the book *Arts in Education Partners, Schools and Their Communities,* available from the Associated Councils of the Arts in New York City.

Here is one brief illustration of how parent and volunteer power can be harnessed to generate support for AGE. A few years ago, two schools in the Minneapolis West Area were consolidated because of declining enrollments. Parents and teachers from each felt that the arts would be a unifying force so they formed an AGE committee and submitted a proposal to the central office to become an AGE school. The request was granted, and the school was given its $500 allocation of "seed" money to help them on their way. In short order this modest sum, amplified by contributions from the PTA treasury, generated funds from local corporations and foundations, the state and local arts councils, and the area superintendent's budget. To this coffer were added the proceeds from a schoolwide car-wash event, a roller-skating party, and the principal's commitment of $1 per child for AGE purposes. Thus, $500 generated more than $5,000 of discretionary money, the most difficult to come by and over which the AGE committee had total jurisdiction.

The prime movers in this effort were the parents who volunteered hundreds of hours to write proposals, solicit funds, and organize the fund raisers so that their "new" school could purchase services, supplies, and the time of a program coordinator. This example not only illustrates parent power but gives you an inkling of how a school can play the seed-money matching game. It also indicates the potential influence parents could exert on their entire school district if only they, too, would consider forming a network across school lines to lobby for the arts in general education.

Consultants and Authorities in the Field: The Answer Depends on the Question

The growing need for "on-site technical assistance" in the arts and education field is being recognized by an increasing number of agencies and organizations, although, at this writing, no one has quite defined what they mean by the term, who is to provide the services, and how they will be funded. My personal bias is to look for help from the practitioners, people at the national, state, and local levels who have credibility and can speak from current experience with schools, arts organizations, community groups, and the like.

Probably the most important thing to remember about consultants is that if you have not identified the general problem, they cannot help you to define or resolve it for yourself. Consultants are catalysts, facilitators, and analysts; they are not witch doctors or soothsayers with *the* magic answer. I hesitate to suggest specific sources of consultant assistance since most problems require a special type of tailor-made service. In broad categories, however, and in addition to League and Coalition of States members, the Department of Education, the two National Endowments, the Kennedy Center's Education program, the professional arts and education associations, and state and local education and arts agencies are good starting points for direct or referral assistance.

Colleges and Universities: Slow but Sure

Colleges and universities are becoming more deeply involved in AGE programs. They are providing student interns and practice teachers, in-service training for generalist and specialist teachers, leadership training for administrators and supervisors, and management training for arts administrators with course offerings in the arts in education. They are developing curriculum materials, conducting field research and evaluation, and opening their doors to precollegiate students to take specialized arts courses.

The main lament one hears from public school people is that all too often the "academics" prefer their ivory tower environment to the rough and tumble of everyday life and are therefore out of touch with and sometimes unsympathetic to the problems of schooling. In addition, they feel that partnerships between schools and institutions of higher education usually end up with the latter telling the former what to do and how and when to do it. Gradual progress is being made on this front, however, and more and more efforts are being collaboratively planned and carried out *in the schools* and on school time. All League sites can provide good examples of this growing symbiosis.

Professional Associations and Teacher Unions: Untapped Resources

There are literally hundreds of national and state professional arts and educational associations, all of which provide a variety of services to their membership. Most of them publish newsletters, magazines, and

occasional books and monographs and many hold an annual con-ference focusing on particular themes or topics. Since these organiza-tions rarely design and operate programs in the schools, their potential power lies in their ability to articulate and advocate the idea of the arts in general education to their constituencies. Unfortunately the field is fragmented, and there is a lack of agreement as to what AGE means and how it is complementary to, not in conflict with, certain professional and organizational aims and interests.

Teacher unions and supervisory associations vary in their promi-nence, power, and influence throughout the country. Although their main purpose is to lobby for, bargain for, and protect the rights of their members, they too hold conferences and workshops, cosponsor educa-tional events and programs, provide consultant services, and publish newsletters and journals. In localities where these groups are strong and vocal, I feel they are still a largely untapped resource and potentially powerful advocates for AGE.

School Boards: Financial and Political Advocates

School boards can be extremely influential in supporting AGE pro-grams. They have the power to make educational policy and financial decisions as well as to formulate requests and recommendations to state and local legislatures. Getting on their agenda with formal presentations and extending invitations to them to visit AGE schools and participate in community events are effective ways of attracting attention. What most people forget is that board members are often parents, too, and there-fore have a personal interest in the quality of their own children's education.

Advisory Committees: Marshaling the Community

Not all AGE programs establish permanent advisory committees. In those that do, these bodies are a potent force for advocacy, steady guidance, and political influence. Representation includes chief school officials, arts administrators, civic volunteers, higher education officials, foundation officers, PTA Council presidents, and other community-action people. Monthly meetings address issues that affect every aspect of program development and assessment and provide an excellent

forum for communication and collaborative community action. In Little Rock, for example, the program owes much of its success to a strong and active advisory group in which Arkansas Arts Center Director, Townsend Wolfe and Inglewood Foundation's Polly Keeler and Frank Mackey have played a prominent role.

Private Foundations and Corporations: Seed-Money Sources

These entities, next to the federal and state education departments, are probably still the most important source of financial support for program planning and development, although frequently business and corporate giving officers prefer to invest in "tangibles," such as artists' services, tickets to performances, exhibitions, displays, conferences, and publications.

With very few exceptions, foundation and corporate officers engage in what is known as "program monitoring." I have long wished that these groups would reexamine their arms-length posture and somewhat arbitrary one-to-three-year funding-cycle policies because:

1. Firsthand experience *over time* generates useful knowledge and a deeper understanding of complex situations.

2. Lessons learned can influence grant-making policy and also be more authentically shared with a larger audience.

3. As Mr. Rockefeller used to say, "Let's not pull up the plant to see if the roots are growing." Innovations need time and nurturing to take hold.

State Education Departments: Natural Mechanisms for Expansion

State education departments can play a major role in disseminating information about and supporting the idea of the arts in general education on a statewide basis. They can declare the arts a priority in the education of every child in the state and design comprehensive plans that assure, among other things, adequate technical and consulting assistance, coordination, and funding.

Through statewide and local networks, leadership-training institutes, staff and curriculum development workshops, certification pro-

cedures, mandates, publications, conferences, and resource people, state education departments can provide leadership to a very broad audience. They can also make money available from a variety of state and federally funded programs and assist in the difficult task of research and evaluation.

Information about the Coalition of States for the Arts in Education and two case studies on Oklahoma and Pennsylvania are contained in *An Arts in Education Source Book: A View from the JDR 3rd Fund,* available from the American Council for the Arts.

Arts and Humanities Agencies and Endowments

These agencies are natural partners for all AGE efforts. They supply money for teacher training, artist residencies, programs and exhibits in the schools, performances and visits to cultural sites and centers, special events, and the production and publication of documentary and dissemination materials. Grants are either outright or on a matching formula basis.

There are many councils, commissions, and federally assisted programs around today, some with long and impressive track records in the arts in education and many of them operative in League cities. I would, however, urge those interested to study the records of the National Endowment's Artists in Education Dance Component coordinated by Charles Rinehart, and the work of the New York Foundation for the Arts directed by Theodore Berger. They both offer comprehensive process models that have been tested and tempered in the field and widely acclaimed by both artists and educators.

The U.S. Department of Education and the Education Program of the John F. Kennedy Center for the Performing Arts

The Department of Education (formerly the Office of Education and the National Institute for Education) has been involved with the arts in education since the early 1960s and the Kennedy Center, since 1970. There are far too many bureaus, divisions, offices, and programs to list here, but generally, the Education Department makes competitive for comprehensive programs and provides categorical money for compensatory and other special efforts.

The Kennedy Center Education Program coordinates and/or administers local and national programs, provides funds for certain developmental projects, and issues a first-rate newsletter, "Interchange," about the arts in education. The Education department, the Kennedy Center, and the two National Endowments frequently collaborate on national and regional conferences, investigative studies and reports, and certain programmatic efforts.

My chief concern with these agencies is the one expressed regarding foundations, businesses, and corporations. I think it would be beneficial if they, too, would reexamine their funding patterns, criteria, and grant styles (which would take some legislative doing) in order to stay with promising efforts for longer than three or four years. Also, while there are recent indications of greater intra- and interagency communication and cooperation, there is still much room for improvement, especially in the areas of collaborative funding, leadership training, technical assistance, and research and evaluation.

SUPPORT SYSTEMS:
WHAT WE HAVE
AND WHAT WE NEED

Leadership Training

In my view, whether you are a chief administrator, supervisor, coordinator, principal, teacher, artist, etc., in an AGE program, there is no real substitute for learning the ropes on the job. There are, however, ways of speeding up the professional development process. I think one of the most effective (certainly cost-effective) ways, as I have said, is through networking where practitioners meet regularly to address the problems they have identified and come up with many solutions that they can apply and test immediately. This method is in effect a "floating" academy run by and for its members, who are regarded as the "experts."

Other methods are:

- Institutes, workshops, seminars and college courses in which national and local leaders and authorities in the field deal with specific conceptual, instructional, and administrative topics and use current material (such as source books, case studies, administrator's manuals, curriculum guides, instructional frameworks, and occasional papers) as references and points of departure. The most effective of these more "formal" approaches always combine task-oriented study with supervised field work and observation of exemplary programs in action. Many of them are offered to a broad audience for professional or service credit.

- Fellowship programs whereby fledgling administrators with a background in both the arts and education are introduced to all aspects of AGE and assigned specific tasks and responsibilities for which they are paid a modest stipend. The Fund's Administrative Fellowship Training Program was a case in point.

We provided the major financial support for the Fellows (approximately $1,000 a month plus travel and expenses), but we deliberately left selection, supervision, and the training process in the hands of each member of the League and the Coalition. (The terms of the grants did, however, include general guidelines and criteria, a request for progress reports, and final evaluations.) In addition, fellows participated in an orientation conference and were included in all network meetings and site visits. League and Coalition members and the fellows, themselves, generally called the program a success. Many of the fellows have continued in their newly created positions or have been assigned other roles and responsibilities, all at the district or state education department's expense.

127

The success, of course, was not unqualified. There were some supervisors who did not "supervise" and instead threw their unprepared and overwhelmed trainees "into the lion's den," as one of the fellows plaintively put it. Some were used as only slightly glorified "go-fers" and given mostly clerical or drudge work.

As anyone who has been involved in internship programs knows, a training program is only as good as the trainer makes it, consciously and by design. There is always plenty of room for creativity and serendipity, but the chances for accidents, especially those that can have disastrous programmatic and political consequences, should be minimized. However, I think the Fund's fellowship program laid the groundwork for a larger national effort.

What we need is an AGE academy or institute that addresses a broad audience of current and potential practitioners and is staffed to some degree by current personnel in the field. It would combine on-the-job training with a structured study of the arts and education and offer opportunities for leadership, staff, and curriculum development. It would be school-practice-oriented and deal with both the theoretical as well as experiential aspects of designing and carrying out an AGE program from the perspective of administrators, teachers, artists, and community volunteers. If such a pilot venture were to prove successful, it would offer another model process for national replication.

Staff and Curriculum Development

What is most difficult to convey to teachers is that the instructional aspect of AGE is in their own heads, hands, and imagination. "Fine," they say, "but where's the curriculum? What's the scope and sequence? What should I be doing and children be learning so that I know I'm teaching AGE?" My answer is always, "You cannot teach AGE as such. It is not a subject and it is not a new or separate scope and sequence curriculum. It is a holistic way of looking at schooling and seeing where the arts fit in."

Since there is no AGE textbook, where can teachers turn for help, guidance, inspiration, and reassurance? The answer to this is, themselves and other teachers. It is small comfort but nonetheless true that, by and large, an AGE "curriculum" is what classroom teachers, kindergarten through high school, make it—supported and augmented by arts specialists and reinforced by artists and other resource personnel. Teachers do need immersion in the arts, knowledge and skills that will make them more comfortable with the processes, and support from

each other and the principal to explore, take chances, make mistakes. But they don't have to be bona fide professional artists to relate the arts to general or subject-area learning.

Each League program has developed a great deal of teacher-made curriculum or arts-related resource materials. Seattle, for example, has developed an "instructional framework" in the form of a matrix which relates the arts process to the general learning process and ties into concepts basic to individual art forms. This novel approach proceeds by developmental and incremental steps (not scope and sequence) and gives tremendous freedom to the teacher to design individual lessons, units, or projects. The framework was planned by a team of teachers, curriculum specialists, and artists under the supervision of a "master teacher" and has been field-tested and reviewed by college and university professors. It is proving successful as an instructional guide for teachers, artists, and principals and as an excellent tool and technique for schoolwide staff and curriculum development efforts.

What we need is an organized campaign to ferret out and collect the best of the materials that already exist not just in the League, but all over the country, so that these nuggets of informational gold can be mined and shared by the broader public that is clamoring for concrete help. What is also needed is an "information clearinghouse" to make these materials more accessible and a directory indicating where they can be obtained or studied. The current educational information "feedback" systems are woefully inadequate when it comes to providing practical counsel on AGE. We also need national, regional, and local AGE teacher networks—of, for, and by teachers. They would probably do more to strengthen curriculum and staff development in AGE programs than any other single effort.

Research and Evaluation

I discovered some years ago that in the arena of educational research and evaluation (of the arts in education), simplicity was considered a dangerous idea. When I would venture that evaluation designs be based on common sense, a broad perspective, and an empirical approach, it was not a framework that most of the professionals respected or chose to use when investigating or judging the effectiveness of an AGE program. There are fortunately a few refreshing exceptions—Elliott Eisner, John Goodlad, and Robert Stake come immediately to my mind. However, most researchers and evaluators prefer elaborate matrixes and insist

matrixes and insist upon a jargon that is so abstract, so obscure, and so unintelligible that I came to a perhaps hasty and certainly nasty conclusion. The language barrier was an intentional smoke screen meant to camouflage a sad fact: research and evaluation of arts in general education programs is, as Kathy once put it, "in a primitive state."

This sounds like a broadside against educational research and evaluation. It also makes no distinction between the purposes and modes of operation of the two fields. One is primarily investigative and descriptive and the other, for the most part, judgmental. Nonetheless, my plea here is for more candor and especially for more collaborative action so that research and evaluation can begin to tell us what we need to know as soon as we need the information, not what the computers say, three years too late.

Let me state the case bluntly: I think I know and so do League members that under certain conditions, AGE programs work. We have a lot of factual knowledge and general hunches why they do, but we cannot seem to persuade "the field" to rely far less on pre- and post-tests, fancy instruments that cost a fortune to administer and decode, and a whole set of "scientific" formulae that treat schools and the people in them as if they were so many dots on a graph or numbers on a computer printout. We want them to rely far more on what is. Look at the schools, interview the people, examine the program *and* the process, observe classrooms. Record, analyze, and interpret what is actually happening. Then compare what *is* with what we said (or thought we said) we set out to do. If we were able to get other and perhaps more objective opinions on what is missing or inadequate, we would be in a much better position to close whatever gaps exist between the real and the ideal.

Let me be even more specific. Throughout this book there are enough goals, objectives, criteria, strategies, processes, and outcomes (actual and anticipated) to provide a framework for a comprehensive evaluation design that would speak to what we, our sponsors, clients, parents, and especially the skeptics and doubters need to know—now. On the basis of the contents of this book, I would propose that the following propositions be thoroughly investigated:

- The quality of general teaching and learning improves significantly for a majority of the children in a school or school system when the arts become part of their daily experience.
- Schools change, develop, and improve through AGE.
- The five main points (interdisciplinary teaching and learning, increased arts offerings, greater use of artists and community

resources, etc.), when in sufficient evidence, collectively charac-
terize a quality AGE program.

- The change theory, which relies on networking and collaboration as an effective strategy for school development, increases community involvement and public support.

- Comprehensive AGE programs add another significant dimension to the quality of the formal education of children and help schools meet the broader aims of education.

- The experience and knowledge which has grown out of the League's experience can easily be drawn upon for planning and implementation in other locations—under certain conditions.

- It takes five to ten years for a new theoretical concept to become an accepted and effective educational practice.

As my colleague, Jack Morrison, who is a bit of an evaluation buff himself, once eloquently put it:

> Questions like the above can be answered in a common
> sense, systematic way and presented to all concerned in
> clear, simple, and persuasive ways. Honest reporting of
> these answers in effective modes that touch the con-
> sumer's sense of caring about children is in the realm of
> the possible. But it takes imagination and insightful in-
> terpretation with great integrity. It means the use and
> respect of subjective data carefully collected and or-
> dered. It means demystifying *objective data* in the sub-
> jective realm of feeling. (Stake et al., *Evaluating the Arts
> in Education: A Responsive Approach* [Columbus,
> Ohio: Merrill, 1975]. The quotation is from the chapter
> entitled "A Consumer's Concern.")

Meanwhile, most of us are somewhat comforted by the fact that since many AGE programs have survived all manner of crises and setbacks, grown in the face (or because) of adversity, and expanded despite a few negative assessments (of only one or two of the program's components), the proof of the value of AGE is apparently in the pudding. If support within and outside of the system is increasing and if other districts are following our example and using our approach, we must be doing something right. What we need, again, is a comprehensive research and evaluation effort to illuminate, reinforce, or temper our experiential confidence.

Documentation and Dissemination

Over the years, I have accumulated a great many books, reports, monographs, and reference materials about the arts and education. Only one quarter of one shelf deals specifically with the topic of the arts in general education as a philosophy and a program, and much of it has been published or financially assisted by the JDR 3rd Fund. Given that the notion has been around for quite a while and now seems to be gaining, or at least maintaining, momentum, one quarter of one shelf does not a reference library make.

I know for a fact that there are literally hundreds of reports, documents, case studies, and other sources of useful information scattered far and wide, not just in the League. The pity of it is that most of it is lying around on dusty shelves, buried in storerooms under piles of paper, forgotten in crammed file cabinets, or simply out-of-print. The rest of it is still unwritten. AGE folk, like most pioneers, have been so busy "doing it" that they have sadly neglected to keep written or visual track of their work. Much of our legacy depends on oral history and a sound memory and those are not, as we know, entirely reliable sources. There is a need for a thorough search and cataloging of all existing information and a conscious and sustained effort to document all aspects of current and future programs so that information about the field is comprehensive, fresh, and easily accessible. We must get organized now, before our collective memories fade.

Financing

Funding for AGE programs has and will never come from a single source, although its operational bedrock should ideally be local tax-levy monies. The name of the game is the identification and reallocation of existing resources, pooling, matching, and "piggybacking" on line-item allocations earmarked for other seemingly unrelated purposes. With a little imagination, a lot of categorical and competitive money can be claimed for use by AGE, since the program's objectives are clearly complementary to or in direct support of many broad educational and social goals.

Rather than provide a laundry list which, without considerable annotation, would be meaningless to the casual reader, I will mention a few general sources of public and private funds for AGE programs and suggest that those interested in more helpful details do some (time-

consuming) research on their own. The funding game is a very intricate and complicated one. It is also in constant flux, especially at the federal level, so that no resource list or directory could ever hope to be complete or up to date.

Federal

- The Department of Education (see especially the Elementary and Secondary Education Act for direct or piggybacking funds; practically every Title can be used to support AGE programs)
- The National Endowments for the Arts and Humanities
- The Kennedy Center Education Program
- The National Parks Service
- The Law Enforcement Agency (Drug Addiction, Juvenile Delinquency)
- CETA (Comprehensive Employment and Training Act)

State

- Education departments
- Arts councils, commissions, boards
- Cultural enrichment programs
- Governor's discretionary budget
- Special legislation

Local

- School districts
- City and county agencies
- Arts councils, cultural commissions
- Foundations, community trusts, businesses, and corporations
- Banks and insurance companies
- Parents associations, civic groups
- Merchants
- Professional associations
- Individual benefactors

What we need is obvious: increased and more sustained financing. Given the current state of the economy and the national inclination

toward greater state and local autonomy in education, it is clear that large sums earmarked for the arts in education will not be forthcoming from federal agencies. The halcyon days of the sixties are gone, and even the modest but significant seed-money sources of the seventies are under scrutiny or threatened from some quarters with extinction. Basic support for AGE has always come from state and local budgets, supplemented by corporate and philanthropic funds. The handwriting is on the wall—a grass-roots program needs grass-roots support. We need now, more than ever, to focus our energies on our own backyard.

One further thought continues to trouble me. When pursuing money for AGE programs, I am always confronted by a philosophical, and in the end, practical problem. Because AGE unites the arts and education and since the JDR 3rd Fund was the only philanthropy I know of that brought the two fields together, does one now ask foundations, corporations, and individuals for "arts" money—or "education" money? Most organizations with individual arts and education units keep their areas of jurisdiction separate, if not isolated, and AGE falls between the cracks.

I continue to feel that it is wisest to hedge the bets and work both sides of the street, hoping that donors partial to the arts will recognize their value to schooling and that those concerned with school improvement and educational change will be willing to support programs that focus on the arts as content and vehicles for the process. Of prime importance, especially these days, is that both "camps" see and understand the value of concerted action and collaborative support. What we need is a united front and a much more vocal constituency.

TALLYING UP AND LAYING THE GAUNTLET DOWN

In Retrospect

Over eight years ago, when Edythe, Kathy, and I decided to form our partnership, we had no grand design for changing schools through the arts. We simply liked and trusted each other and believed that together we might do something important for the schools, the arts, and the kids. Certainly, we believed, the arts were valid subjects of study in and of themselves; surely, they could be used as tools and metaphors for learning other things; by all means, they could bring the community, especially artists, parents, and other resources, into the schools and get the kids out into the museums, zoos, concert halls, and theaters. Clearly, they could speak to special populations and their unique needs—the gifted, talented, handicapped, and so forth. And obviously, they could help reduce racial and personal isolation simply because putting on a show, designing an exhibit, or building a display case would automatically result in kids working together to solve common problems on group subjects.

But the idea that the arts could qualify as a motive, an organizing principle, a force for total school change was actually born out of necessity probably because we started from two imperatives: the mission of the Fund—all the arts for all the children in entire schools—and Edythe's passion—school development under the creative leadership of the principal. That we wedded the two and that a school change through the arts program was conceived, born, and nurtured in the Big Apple and then taken over and elaborated upon by five other urban centers was a marvelous bonus for all concerned.

Bonus or no, school change through the arts and the formation of the League and its refinement of the AGE concept constitute an interesting page in American educational history. In this final chapter, I will describe what I perceive to be the League's significance and comment on its current status. My last words will be a call for action. Words are fine, but for me, it's deeds that count.

The Significance of the League

In summing up, it seems to me that the significance of the League has been:

1. *Starting from individual partnerships, six school districts formed a national network for the arts in general education.*

Six urban school systems of widely different size, geographical location, and structure agreed to form individual partnerships with a private foundation and, in a short time, decided that it would be mutually beneficial to establish a national network. This network met regularly and worked together in common cause with the understanding that differences were to be both respected and cherished. The network served its members well. Their local programs are for the most part flourishing.

2. *The New York City plan became the basis for the League's programs and the model process by which these efforts were planned and developed.*
A plan that was originated in New York City quickly became the League's model process for school change and development through the arts. Collective ownership and experience refined, altered, extended, and in some cases gave more practical meaning to theoretical ideas, but the basic goal and general approach remained intact. It is interesting to note that the fundamental principles of networking and collaboration which were spelled out in "Design for Change" almost a decade ago proved viable for individual schools in New York City and for many other school districts nationally.

3. *The process model is specific but flexible and adaptable.*
The League's model process is not a single rigid formula with a set of unalterable strategies to be followed in lockstep fashion. Rather, since the process has already been orchestrated into six variations on a theme in which each program reflects local needs, conditions, and opportunities, it offers a variety of flexible options to school systems interested in following a similar course. Schemes for management and coordination, specific program content and emphases, approaches to leadership, staff and curriculum development, and the means for expanding the program from a small network of demonstration schools to a much larger number of schools are highly individual.

4. *The power of the idea—all the arts for all the children— speaks to a broad audience. Its strength is doubled when coupled with faith in public education, a change theory, and an approach that makes it work in spite of many obstacles.*

The power of an idea that speaks to the improvement of the quality of education and equality of educational opportunity for every child regardless of race, national origin, religion, social background, sex, aptitude, or special ability is one which has caught and manages to sustain the attention of a broad audience. The slogan "all the arts for all the children" is compelling; no art and no child is left out. Even in the face of social stress, shrinking budgets, systemwide overhauls, declining enrollments, and a generally reduced teacher force, the idea is appealing to decision makers because it seems to promise solutions to broad educational, economic, political, and social questions.

5. *The idea does not depend on massive sums of money in order to work.*
 In order to make this idea work, a great deal of extra money and personnel are not required for basic program operation. In fact, many of the resources required already exist at the local, state, and federal levels. Much more, of course, is needed for artists' services, teacher training, planning and developmental activities, documentation, research, evaluation, and dissemination. Most good programs have been able to attract resources. "Matching," "piggybacking," "parlaying," and "pooling" are key strategies for solving the funding problem.

6. *The programs focus on broad educational needs and try to build the arts into the very fabric of schooling.*
 These programs focus on the broad educational needs of every child. The proposition is not what the schools can do for the arts, but what the arts can do for the schools and the general education of every youngster. Special programs and cultural-enrichment efforts for a limited number of students are no longer regarded as cost-effective or politically wise these days. If the arts are built into the very fabric of schooling, the hope is that no matter how bad things get, these programs won't be cut because there will be no way of extricating the arts from the basic curriculum and regular school practice.

7. *School change through the arts has finally come of AGE: it toes the current Pedagogical Party line.*
 School change and development through the arts is a notion

that has finally gained credence and prestige. An increasing number of educators and researchers believe that the key to progressive change in schooling is the individual school taking charge of its own destiny and working in concert with other schools to explore and advance a particular philosophy or set of ideas. The programs developed by the League are based on this idea, which proceeds from a simple notion: those who are responsible or held accountable for results must be involved in the organization or circumstances that produce them; they must have a stake in the action.

8. *AGE programs demonstrate both the intrinsic value of the arts and their usefulness for achieving broader educational goals.*
 The League has been able to demonstrate and to some extent document how the arts, artists, and the arts process are valuable not only because the arts are in themselves rewarding but because they can be personally, socially, and politically useful; they can help schools meet the broader aims of education.

9. *League members are important advocates for AGE and have influenced national opinion and the development of many arts in education efforts.*
 The League has provided moral support and leadership training for its members, a forum for debate, and a tangible field available for inspection. It has also influenced national opinion about the arts in education and provided resource materials, manuals, and direct technical and consulting assistance to the Education department, the two National Endowments, foundations, professional arts and education associations, state education departments, school districts, and arts agencies and organizations.

10. *League programs have helped create a more favorable climate of opinion for public education.*
 The League has served public education well. Its programs strengthen the scant testimony regarding what is right with education and particularly what is good and successful in urban public schooling. For years now, the media and the press have been on a rampage. For them, good news is no news and every incident (usually sensational) is blown up out of all proportion, presented out of context, and almost always biased. Although recent articles in the *New York Times, Time,*

Newsweek, and *New York* magazines have been surprisingly balanced, a quick look at the titles of books on education reinforce the alarmist and negative attitude toward our schools: *Crisis in the Classroom, Why Johnny Can't Read, How Children Fail, Teaching as a Subversive Activity, Our Children Are Dying,* and *Nobody Gives a Damn* are just a few examples. What the League has done, and what the power of the idea of the arts in general education has enabled it to do, is to help counterbalance public skepticism and soften critical public opinion. We still have a long way to go, but AGE has made a few important friends and quite a number of admirers.

Current Status: Six Cities in Search of a Hub

The League made considerable progress in achieving the goal and objectives outlined in its Mission Statement and Declaration of Intent. The one purpose it did not fulfill was the production of a notebook which would describe the AGE programs. Although, as I have said, we spent a considerable amount of time at business meetings working on this project, Mr. Rockefeller's untimely death brought our collective efforts in this direction to an abrupt halt. Obviously, I took it upon myself to try to get at least part of the job done for all of us.

The League is currently in a "holding pattern." We are, as my New York City colleague Arnold Webb (Dean of Education, City College of New York) so aptly put it, "much like six cities in search of a coordinating hub—with apologies to Pirandello." We keep in touch by phone and by mail and have met formally (and at each district's expense) to examine alternatives for keeping the network alive. We are keenly aware that either we need to find another institutional base whose mission is complementary to our own or to form an independent organization whose purpose would be to:

- Continue to support and expand the League and help form or participate in other arts and education networks at the local, state, and national levels

- Provide technical and consulting assistance to the growing number of people who seek advice in the planning, development, and execution of their own programs

- Welcome others to League schools and districts to study and learn from on-going programs

- Participate in research, evaluation, and dissemination efforts about the arts in general education

The desire of the group to stay together persists as does its eagerness to share the increasingly sophisticated experience of people who have been engaged in a long-term, field-tested effort. While it would be a misfortune if the League were to disband altogether, I am fairly confident that most of the districts will continue to refine and expand their programs.

A Call for Action: A National Task Force on the Arts in General Education

In some of the preceding chapters I have identified some urgent needs. Among them are:

- Leadership training programs (academies, institutes, etc.) for current arts and education administrators, supervisors, teachers, artists, and others who work in or with AGE programs
- AGE networks for teachers at the national, state, and local levels
- Orientation and training programs for artists
- A network of information clearinghouses
- Staff and curriculum development programs at the national, regional, state, and local levels
- A comprehensive research and evaluation effort
- A similar documentation, dissemination, and advocacy effort
- Money to plan, coordinate, and operate all the above

The groundwork for most of these efforts has been laid; the talent bank of experienced practitioners and other authorities exists; the "raw material" for staff and curriculum development abounds; and programs, including but certainly not limited to those in the League, are available for study and documentation. But as the needs are comprehensive, the grand design for meeting them must be equally encompassing.

I will end by laying the gauntlet down: I call for a national task force on the arts in general education to examine current needs and opportunities and to propose a comprehensive long-range plan of action. We owe it to ourselves and to our schools. Our children deserve nothing less.

APPENDIX

Appendix A

Artists and Schools: Some Guidelines for Effective Partnerships*

* Reprinted by permission, The JDR 3rd Fund ©1980

CRITERIA: "Community Arts Programs and Educational Effectiveness in the Schools

I. HIGHEST LEVEL OF EDUCATIONAL EFFECTIVENESS

A. *The form, content, and structure of the program grow out of a cooperative effort* by school personnel (teachers, curriculum specialists, administrators), artists, and arts organization representatives and are related to and supportive of the content of teaching and learning in the schools.

B. *Programs are planned as an on-going series of related educational events.*

C. *The program includes the participation of artists who serve as resources to teachers and students* in a variety of direct teaching and learning activities. These include creative experiences or demonstrations of the techniques, skills, and talents indigenous to their particular profession.

D. *Preparatory and follow-up curriculum materials* planned specifically for the program are provided to the schools. These materials result from work done jointly by school representatives, artists, and arts organization educational staff. Related visual and written materials and resources such as slides, recordings, tapes, films, reproductions, and teacher's guides are available in the schools and used by teachers in classrooms.

E. *In-service training is available to teachers* in order that they have general understanding of the arts organization, its purposes, its resources, and the nature of its services in terms of curriculum development.

F. *Orientation and training are available to artists and arts organization educators* so that they have an understanding of the nature of schools, the content of the educational program, and the learning characteristics of students at different age levels.

G. As a result of the foregoing, *the arts event becomes part of the process of teaching and learning,* not just a "field trip," time off from school work, or another assembly program.

145

II. MIDDLE LEVEL OF EDUCATIONAL EFFECTIVENESS

A. The content of the program is planned by arts organization educators with some help from school personnel, but is not focused on the content of school studies.

B. Programs are isolated and sporadic events.

C. Contact with artists is limited.

D. Some preparatory materials are provided to the schools for the arts events. Few related materials are available in the schools.

E. No in-service training is available to teachers. Often they have no more information about the arts event or organization than the children they accompany.

F. No training is available to artists or arts organization educators. They assume an automatic interest or curiosity on the part of teachers and children. Capability to work with different age groups is learned on the job by trial and error.

G. The arts event is of some value to children and teachers but remains separate from the larger educational program of the schools.

III. LOW LEVEL OF EDUCATIONAL EFFECTIVENESS

A. The content of the program is accidentally determined by the fact that the arts organization has a special event it feels has some significance for the schools, and the schools decide to send all fifth grade classes and their teachers to it.

B. Programs are single, isolated, unrelated events or activities.

C. Artists are not involved as resources to teachers and students in the program.

D. No preparatory or follow-up materials are available.

E. No in-service training is available for teachers.

F. Arts organization representatives do not work with teachers and students since their regular responsibilities make very heavy demands on their time, or the schools have not made appointments for their classes in advance.

G. Educationally, the arts event is of dubious value to students and teachers.

The Role of the Artist in School-Development Programs

I. AS ARTISTS, THEY:

- Demonstrate their art form as a process and a product
- Stimulate curiosity about their professional trade and respect for the diligence and discipline required for excellence
- Provide role models and open new options for professional or amateur pursuit
- Help identify the artistically gifted and talented
- Work effectively with special populations using the art form as the language and medium for communication
- Bring normally isolated individuals together to work on group projects
- Generate community interest in the arts and the schools

II. AS "RESOURCE TEACHERS," THEY:

- Discuss, interpret, and illuminate the origin, history, and development of their field
- Develop basic artistic abilities and problem-solving skills
- Demonstrate how others can create their own activities or products using the arts
- Make connections between the arts process and the learning process and help find ways to relate the arts to each other and to mathematics, science, social studies, language arts, etc.
- Help build curriculum frameworks, guides, units of study, and other instructional and resource materials

III. AS TRAINERS, THEY:

- Provide or participate in staff-development workshops and courses for entire or partial school faculties and community
- Orient and train other artists for school work

IV. AS ADMINISTRATORS AND COORDINATORS, THEY:

- Help schools establish linkages with arts organizations, community agencies, and vice versa
- Build bridges among schools and between a school and the central administration
- Organize arts resource teams and schedule visits and services
- Document activities and evaluate progress

Joint Planning: Some Questions to Raise

1. Acknowledging that the main institutional purpose of arts and education groups differs significantly, where do interests and capabilities converge or coincide?

2. Is this to be a partnership where both parties discuss and agree on mutual and limited goals, objectives, activities, and responsibilities in light of existing realities (resources, time, structure, organization), or will one side attempt to dictate all terms and conditions to the other?

3. Will the process used be one of negotiation and consensus to assure the best possible accommodation and compromise, or will one or both parties make arbitrary decisions without consulting the other?

4. Are the participants ready, able, and willing to spend the considerable time and energy necessary to plan, review, adjust, and assess mutual efforts?

5. If an effort falters or fails, who gets the blame, and if it succeeds, who gets the credit?

6. Who pays for what, directly or indirectly, and who seeks addi-

tional outside support from whom? Will support be secured by pooling scarce resources and collaborative fund raising?

Profile of a One-Week Artists' Residency in an AGE School

Phase I: Orientation and Planning (Assess School Needs and Meet the Artists)

- The AGE planning committee, in consultation with the school staff, parents, and students, decides which art form or forms would be most beneficial to the total school in light of its comprehensive plan. Decisions are made as a result of answers to questions such as:

 1. How can the artists and the art forms they represent be used most effectively to help the school strengthen existing arts programs and/or expand into new areas; promote more interdisciplinary teaching and learning; meet the special needs of students; and reduce personal, racial, or structural isolation?

 2. How will every student and teacher in the school be involved or positively affected, directly and indirectly?

 3. What strengths and resources now exist on the staff, in the school, and in the community to support and extend the workshops (performances, residencies, other events) once the artists have gone?

 4. What must be secured, done, or changed (resources, scheduling, released time for teachers, transportation, space, materials, books, supplies, etc.)?

- The AGE planning committee and the total staff meet with prospective artists to describe the school's overall philosophy, current status, and perceived needs. The artists respond with a description of how they work best and state their goals, conditions, and expectations. Discussions are frank, open, and informal. The school and the artists agree to work together and to negotiate the goal, shape, content, schedule, and number of participants in the residency.

- Subsequent meetings are scheduled to explore programmatic issues in depth, spell out roles and functions, and define the individual and mutual expectations of all participants.
- A schedule is drawn up and widely distributed.

Phase II: Implementation (The Residency)

- The schedule includes provision for:

1. An informal gathering to introduce the artists to the school community and other interested or important people (sponsors, legislators, officials)

2. Training workshops, during and/or after school for all or part of the supervisory and instructional staff and parents. These workshops are open to other AGE network schools, and there is released time for teachers

3. Weekly or daily planning time for artists, supervisors, and teachers (separately and together) to assess progress, make adjustments, and refine goals and expectations

4. Class and room assignments, and identification of artists' temporary headquarters in the school

5. Descriptions of individual projects, activities, and events

6. Performances, lecture-demonstrations, and exhibits for the school community during the day and in the evening

7. Social occasions and fund-raising events

8. A final meeting for assessment and recommendations for the future

9. Unexpected and unforeseen opportunities

Phase III: Follow-Up (After the Artists Leave)

- The normal school schedule, which has usually been pretty much

disrupted, is reinstated and all participants take time to digest, analyze, and savor the residency experience.

- Core teachers and supervisors continue to offer staff and curriculum development workshops before and after school, at faculty meetings, and in AGE network meetings and conferences. They also work with curriculum supervisors (often in tandem with artists) at central headquarters to develop guidelines and manuals based on their own experience for distribution to all AGE and other interested schools.

- Core students form committees, write newspapers, broadcast over the public address system, and share their new knowledge and skills with other students.

- Parents and community volunteers work more often in the school(s), raise funds, and publicly advocate the value of AGE to the school's overall instructional program.

- The principal, the AGE committee, and others review their comprehensive plan and decide on the next developmental steps.

Appendix B

The League of Cities for the Arts in Education: Addresses

Hartford Public Schools
Central Administrative Offices
249 High Street
Hartford, Connecticut 06103

Little Rock Public Schools
West Markham and Izard Streets
Little Rock, Arkansas

Minneapolis Public Schools
807 Northeast Broadway
Minneapolis, Minnesota 55413

New York City Board of Education
Division of Curriculum and Instruction
131 Livingston Street
Brooklyn, New York 11201

Seattle Public Schools
815 Fourth Avenue North
Seattle, Washington 98109

Winston-Salem/Forsyth County Schools
Post Office Box 2513
Winston-Salem, North Carolina 27102

SELECTED BIBLIOGRAPHY

All the Arts for All the Children: A Report on the Arts in General Education, New York City, 1974–'77. New York: New York City Board of Education, 1978.

Architecture: A Design for Education. New York: New York City Board of Education, Division of Curriculum and Instruction, 1979.

"The Arts in General Education," *Music Educators Journal,* vol. 64, no. 5, January 1978, entire issue.

Arts in General Education: An Administrator's Manual. New York: New York City Board of Education, Division of Curriculum and Instruction, 1979.

A New Wind Blowing: Arts in Education in Oklahoma Schools. Oklahoma City: Oklahoma State Department of Education, 1978.

Bentzen, Mary M. *Changing Schools: The Magic Feather Principle* (|I|D|E|A| Reports on Schooling, a Charles F. Kettering Foundation Program). New York: McGraw-Hill, 1974.

Bloom, Kathryn. *The Arts in Education Program: Progress and Prospects.* New York: The JDR 3rd Fund, 1976.

————. *Arts Organizations and Their Services to Schools: Patrons or Partners?* New York: The JDR 3rd Fund, 1974.

Coming to Our Senses: The Significance of the Arts for American Education (a report by the Arts, Education and Americans Panel). New York: McGraw-Hill, 1977.

Comprehensive Arts Planning: Ad Hoc Coalition of States for the Arts in Education. New York: The JDR 3rd Fund, 1975.

Dobbs, Stephen M. (ed.). *Arts Education and Back to Basics.* Reston, Va.: National Art Education Association Publication, 1979.

"The Ecology of Education: The Arts," *The National Elementary Principal,* vol. 55, no. 3, January/February 1976, entire issue.

Eddy, Junius. *Arts Education 1977—In Prose and Print: An Overview of Nine Significant Publications Affecting the Arts in American Education.* The Arts and Humanities Program, Office of Education, U.S. Department of Health, Education, and Welfare Publication 260–934/2044, 1978.

————. *A Report on the Seattle School System's Arts for Learning Project.* Seattle: Seattle Public Schools, 1978.

Fowler, Charles B. (ed.). *An Arts in Education Source Book: A View from the JDR 3rd Fund.* New York: The JDR 3rd Fund, 1980. (Kathryn Bloom,

Junius Eddy, Charles Fowler, Jane Remer, and Nancy Shuker, co-authors. Distributed by the American Council for the Arts, 570 Seventh Avenue, New York, New York 10018.)

————. *The Arts Process in Basic Education.* Harrisburg, Pa.: Pennsylvania Department of Education, 1973.

————. *Dance as Education.* Washington, D.C.: the National Dance Association, an Association of the American Alliance for Health, Physical Education and Recreation, 1977.

Gary, Charles L. *(ed.). Try a New Face.* Washington, D.C.: Office of Education, U.S. Department of Health, Education, and Welfare Publication (OE) 79–7305, 1979.

Goodlad, John I. *The Dynamics of Educational Change.* |I|D|E|A| Reports on Schooling, a Charles F. Kettering Foundation Program. New York: McGraw-Hill, 1975.

————. *What Schools Are For.* Phi Delta Kappa Educational Foundation, 1979.

Hausman, Jerome J. (ed.). *Arts and the Schools.* New York: McGraw-Hill Book Company, 1980.

Laybourne, Kit (ed.). *Doing the Media—A Portfolio of Activities and Resources.* New York: The Center for Understanding Media, 1972.

Madeja, Stanley S. *All the Arts for Every Child.* New York: The JDR 3rd Fund, 1973.

————. (ed.). *Arts and Aesthetics: An Agenda for the Future.* St. Louis, Mo.: CEMREL, Inc., 1977.

————. (ed). *The Arts, Cognition, and Basic Skills.* St. Louis, Mo.: CEMREL, Inc., 1978.

————. (ed.). *Curriculum and Instruction in Arts and Aesthetic Education.* St. Louis, Mo.: CEMREL, Inc., 1980.

————. (ed) *The Teaching Process and Arts and Aesthetics.* St. Louis, Mo.: CEMREL, Inc., 1979.

Morrison, Jack. *The Rise of the Arts on the American Campus.* Carnegie Commission on Higher Education series. New York: McGraw-Hill, 1973.

Murphy, Judith, and Lonna Jones. *Research in Arts Education: A Federal Chapter.* Office of Education, U.S. Department of Health, Education, and Welfare Publication (OE) 76–02000, 1978.

Newsome, Barbara Y., and Adele Z. Silver. *The Art Museum as Educator: A Collection of Studies as Guides to Practice and Policy.* Berkeley: University of California Press, 1977.

Remer, Jane. *Networks, the Arts and School Change.* New York: The JDR 3rd Fund, 1975.

RITA: Reading Improvement through the Arts. Albany, N.Y.: The New York State Education Department, Division of Federal Educational Opportunity Programs, Title I, ESEA, and the Division of Humanities and Arts Education, 1979.

Shapiro, Stephen R., Richard Place, and Richard Scheidenhelm. *Artists in the Classroom.* Hartford, Conn.: Connecticut Commission on the Arts, 1973.

Shuker, Nancy (ed.). *Arts in Education Partners: Schools and Their Communities.* Jointly sponsored by the Junior League of Oklahoma City, the Arts Council of Oklahoma City, Oklahoma City Public Schools, the Association of Junior Leagues, and the JDR 3rd Fund, 1977. (Available from ACA Publications, 570 Seventh Avenue, New York, New York 10018.)

Smith, Ralph A. *Aesthetic Concepts and Education.* Urbana: University of Illinois Press, 1970.

Stake, Robert E. *Evaluating the Arts in Education: A Responsive Approach.* Columbus, Ohio: Merrill, 1975.

Toward an Aesthetic Education. Reston, Va.: The Music Educators National Conference and CEMREL, Inc., 1970.

Tye, Kenneth A., and Jerrold M. Novotney. *Schools in Transition: The Practitioner as Change Agent.* |I|D|E|A| Reports on Schooling, A Charles F. Kettering Foundation Program. New York: McGraw-Hill, 1975.

Weinstein, Gerald, and Mario D. Fantini. *Toward Humanistic Education, A Curriculum of Affect.* New York: Praeger University Series, 1970.

Index

Adams, James, 111
Administrative role of artists, 148
Advisory committees, 35, 120–121
AGE (Arts in General Education) program, definition of, 6–7
Aguirre, George, xv
Alliance for Arts Education,/Kennedy Center, 41
American Council for the Arts, 122
Arbital, Ida, 70
Architecture Bulletin (New York City Board of Education), 72
Architecture-in-Residence Program of National Endowment for the Arts, 71
Artists:
 residency of, in an AGE school, 149–151
 role of, 112–116, 147–148
 training and orientation of, 145
Arts Coalition Northwest, 93, 104
Arts in Education Administrative Fellowship Training Program, 86
Arts, Education in America, Inc., 41
Arts in Education Partners, Schools and Their Communities (Associated Councils of the Arts), 118
Arts in Education Sourcebook, An: A View from the JDR 3rd Fund, (American Council for the Arts), 122
Arts in General Education (AGE) program, definition of, 6–7
Arts and humanities agencies, 36
 and endowments, 122, 133
 (See also entries beginning with terms: National Endowment)
Arts-related career opportunities, 51
Arts Resource Teams, 116–117
Arts specialists, 112
Associated Councils of the Arts, 118

Bank Street College of Education (New York City), 14

Beacon Light School, network of Learning Cooperative (New York City), 16
Berger, Theodore, S., 60, 122
Bloom, Kathryn, 12, 14, 28, 48, 52, 81, 97, 112–114, 137
Brooklyn Academy of Music, 71
Brooklyn College, 64–65
 School of Education, 71
Brooklyn Museum, 71
Business meetings of League of Cities, 89–90

Calvé, Camy, xv
Career opportunities, arts-related, 51
Carter, C. Douglas, 111
Central Midwestern Regional Educational Laboratory (CEMREL), 20
CETA (Comprehensive Employment and Training Act), funding from, 133
Change process in education, 85
Coalition of States for the Arts in Education, 86–87, 119, 122, 127
Collaboration (see Networking and collaboration)
Colleges, involvement of, in AGE programs, 119
Comins, Eleanor, 69–70, 75
Communications network for AGE schools, 84
"Considerations for School Systems Contemplating a Comprehensive AGE Program" (Remer), 31
 (See also Process model)
Consultants, 118–119
Consultative schools, 22–23
Cooperating schools, 22
Coordinators, artists as, 148
Corporations, financial support from, 121
Creative use of resources, 83
Creativity, arts as tangible expression of, 50
Cultural resource organizations, 36
Curriculum development, 84, 128–129

159

Dance Component of National Endowment for the Arts (Artists in Education Program), 122
Davis, John, 81
Declaration of Intent (League of Cities), 88–89
"Definition of a Comprehensive Arts in General Education Program" (Remer), 52
Demonstration schools, 22
(*See also* P.S. 152)
Department of Education (*see* Education, U.S. Department of), 41
Desegregation, 40
funds for, 76, 77
"Design for Change," 13, 28
Dissemination of AGE information, 132
Documentation of AGE programs, 132
on-going internal and external system of, 84
Duncan, Isadora, 6
Dylan, Bob, 72–73

Edmonds, Ronald R., 102
Education:
change process in, 85
special, 51
Education, U.S. Department of, 119, 122–123
Alliance for Arts Education Program of, with Kennedy Center, 41, 122–123
funding from, 133
Educational effectiveness, levels of, 145–147
Educational research, 129–131
Eisner, Elliott, 129
Elementary and Secondary Education Act (ESEA), 133
Title III grants (Urban Arts Program), 93
Title IV-C grants, 41, 102
Emergency School Aid Act:
desegregation funds of, 76, 77
Special Projects Act of, 41

Evaluating the Arts in Education: A Responsive Approach (Stake et al.), 131
Evaluation of the arts in education, 129–131
on-going internal and external system of, 84
Exxon Education Foundation, 5

Federal financing, 133
Financing of arts programs, 121, 132–134
and school board support, 120
Fineberg, Carol, 11, 42, 102
Foundations, financial support from, 121, 133
(*See also specific foundations, for example:* John D. Rockefeller 3rd Fund)
Frank, Charlotte, 102

Gaines, Edythe J., 11–14, 16, 22, 26, 28, 48, 57, 81, 113, 137
Goodlad, John I., 20, 45, 55–56, 97–99, 129
Growth through Art and Museum Experience (GAME), 116

Hartford, Connecticut, AGE program in, 3, 31, 57, 81, 92, 151
Hausman, Jerome, J., 97
Hoerlein, Paul, 6
Humanistic concept of schooling, 84–85

Inglewood Foundation (Little Rock, Arkansas), 92, 121
In-service teacher training, 145
Institute for the Development of Educational Activities (|I|D|E|A|), 97

Jefferson County, Colorado, JDR 3rd Fund
 project site in, 97
John D. Rockefeller 3rd (JDR 3rd) Fund:
 Administrative Fellowship Training
 Program of, 127
 Arts in Education program of, 3, 5,
 14–15, 134
 documentation and dissemination
 assistance from, 132
 and League of Cities, 81–88
 Study of Schooling supported by, 97
John F. Kennedy Center for the Performing
 Arts, (*see* Kennedy Center Education
 Program)
Julia, Raul, 101
Junior League, 34, 42, 81, 103, 117

Kaplan, Fran, 70
Keller, Polly, 121
Kennedy Center Education Program
 (Washington, D.C.), 41, 119, 122–123
 collaboration with U.S. Department of
 Education, 41, 122–123
 funding from, 133
Kerr, Arthur, xv
Kettering Foundation, 97

Law Enforcement Agency, funding from,
 133
Leadership training, 127–128
League of Cities for the Arts in Education,
 3–5, 119, 127
 addresses of headquarters, 151–152
 business meetings of, 89–90
 current status of, 141–142
 formation of, 86–88
 identification of members of, 81–82
 Mission Statement and Declaration of
 Intent of, 88–89, 141
 process model of (*see* Process model)
 significance of, 137–141
 site visits of, 90–91

Learning Cooperative (New York City), 11,
 12, 20
 Beacon Light School network of, 16
 Urban Resources Linkage Prototype of,
 11
Lincoln Center Education Department
 (New York City), 11, 113, 116
Little Rock, Arkansas, AGE program in, 3,
 31, 81, 92, 111, 121, 151
Local financing, 133
Lucas, Pat, xv

Macchiarola, Frank, 102
Mackey, Frank, 121
McCormack, Elizabeth, xv
McGraw-Hill, Inc., 5
McKeever, Porter, xv
Madeja, Stanley, 20
Maintenance personnel in school
 development, 47
Mineola, New York, JDR 3rd Fund project
 site in, 97
Minneapolis, Minnesota, AGE program in,
 3, 31, 81, 93, 118, 151
Mission Statement (League of Cities),
 88–89
Moberly, David, 104
Morrison, Jack, 97, 104, 131

National Endowment for the Arts:
 Architecture-in-Residence Program of,
 71
 Artists in Education Program of, 41, 119,
 133
 Dance Component of, 122
National Endowment for the Humanities,
 41, 119, 133
National Institute of Education, 41, 122
National Parks Service, funding from, 133
National Task Force on the Arts in General
 Education, proposed, 142

Networking and collaboration, 12–13, 36, 95–107
 benefits of, 104–105
 definition of, 98–99
 and expansion of programs, 39–42
 in New York City, 100–103
 reorganization of, 38–39
 in Seattle, Washington, 103–104
New York City, AGE program in, 3, 31, 97, 152
 criteria for participation in, 23–25
 networking and collaboration in, 12–13, 100–103
 origin of, 9–20, 48
 in P.S. 152 (see P.S. 152)
 school identification process for, 20–22, 25–27
 special grants to, 86
New York Foundation for the Arts, 5, 41, 71, 122

Office of Education, U.S., 122
Oklahoma City, Oklahoma, JDR 3rd Fund project site in, 20, 97
Open Doors (Oklahoma City), 116
Orientation:
 and planning (see Planning)
 and training (see Training)

Parents:
 importance of participation of, 117–118
 in school development, 47
Performing Tree, The (Los Angeles), 116
Personal expression through the arts, 50
Planning, 34–35, 148–149
 by artists-in-residence, 149–150
 coherent and collaborative approach to, 83
 joint, questions to raise in, 148–149
 and level of educational effectiveness, 145
 of New York City AGE program, 19–20

Portland, Oregon, JDR 3rd Fund project site in, 97
Principal Magazine, 49
Principals:
 as leaders, 72–75
 in school development, 46–47
Private foundations, financial support from, 121, 133
 (*See also specific foundations, for example:* John D. Rockefeller 3rd Fund)
Process model, 29–42, 138
 and concept of AGE, 32
 conditions for program success in, 33
 initiation of programs in, 34–36
 mid-course corrections in, 38–39
 and networking, 39–42
 school development in, 36–38
Professional associations, 119–120
Professionals in school development, 47
Program management, identification of personnel for, 35
P.S. 3 (Manhattan), 14
P.S. 51 (Manhattan), 14
P.S. 152 (Brooklyn), 61–78
 climate and environment of, 67–68
 principal as leader in, 72–75
 problems at, 75–77
 profile of, 64–65
 teaching and learning process in, 69–72
 typical day at, 65–67

Quality control by arts specialists, 112
Quality education, commitment to, 83

Rationale for arts in education, 49–52
Reinhart, Charles, 122
Reiser, Diane, 71
Remer, Jane, 31, 52, 82
Research, educational, 129–131
Residency of artists in an AGE school, profile of, 149–151

Resource Personnel Program (Lincoln Center), 113
"Resource teachers," artists as, 147
Resources, creative use of, 83
Rockefeller, Blanchette, xv
Rockefeller Brothers Fund, 41
Rockefeller, John D., 3rd, 3, 86, 121, 141
Rockefeller Foundation, 97

School aides in school development, 47
School boards, AGE support from, 120
School development, 36–38, 43–60
 and broader educational aims, 55–57
 characteristics of, through the arts, 52–53
 concept of, 45
 conditions of, 47–48
 people in, 46–47
 process of, 45–46
 role of artists in, 147–148
School identification process, 20–27, 35–36
 categories of schools for, 22–23
 and considerations for school systems interested in AGE programs, 31–42
 and criteria for AGE participation, 23–25
 outcomes of, 25–27
Scribner, Harvey, 12
Seattle, Washington, AGE program in, 3, 31, 81, 92, 93, 97, 103–104, 152
Seed-money sources, 121
Self-awareness through the arts, 50
Senteio, Charles, 57
Shapiro, Herbert, 63, 64, 66–68, 70, 72, 74–75, 77
Shaw, George Bernard, 72–73
Site visits, 23–24, 90–91
Special education, 51
Staff Bulletin (New York City Public Schools), 13
Staff development, 84, 128–129
Stake, Robert, 20, 129, 131

State education departments, 121–122, 133
State financing, 133
Stein, Gertrude, 112
Students in school development, 47
Study of Schooling (Goodlad), 97
Sutton, Sharon, 68, 71

Task force:
 for school identification, 35
 on the arts in general education, 142
Teachers:
 in-service training of, 145
 "resource," artists as, 147
 role of, 111
 in school development, 47
Teachers unions, 75, 119–120
Teachers and Writers Collaborative, 116
"Ten Characteristics of School Systems that Have Developed Effective Arts in General Education Programs" (Remer), 82
Thompson, Ray, 104
Title III grants (ESEA; Urban Arts Program), 93
Title IV-C grants (ESEA), 41, 102
Toklas, Alice, B., 112
Touchstone (New York City), 116
Training:
 leadership, 127–128
 role of artists in, 148
 for teachers and artists, 145

United Federation of Teachers, 75
Universality of arts, 50
Universities, involvement of, in AGE programs, 119
University City, Missouri, JDR 3rd Fund project site in, 20, 97
University of California at Los Angeles, Graduate School of Education of, 97

Urban Arts Program (Title III grants, ESEA-
 funded), 93
Urban Coalition, 42, 102
Urban Resources Linkage Prototype (New
 York City), 11

Volunteers:
 in AGE programs, 42, 117–118
 in school development, 47

Webb, Arnold, 141
Wenner, Gene, 97
Whiteman, Nola, 11
Winston-Salem, North Carolina, AGE
 program in, 3, 31, 81, 93–94, 111,
 152
Wolfe, Townsend, 121

Young Audiences, 11, 112, 116

About the Author

JANE REMER has spent most of her professional life in the arts as a dancer, musician, actress, and teacher and has held the position of Assistant Director of Education at Lincoln Center for the Performing Arts. Most recently, she has been Associate Director of the Arts in Education Program of the John D. Rockefeller 3rd Fund wherein she designed and executed school arts programs in New York and throughout the country. Ms. Remer has degrees from Oberlin College and Yale University.